# HIDDEN HISTORY

# *of*

# DOWNTOWN ST. LOUIS

*Maureen Kavanaugh*

THE
History
PRESS

Published by The History Press
Charleston, SC
www.historypress.net

*Cover images*: Betty Grable, 1942 publicity shot taken by Frank Powolny. 20th Century Fox studio promo portrait. Author did not renew copyright. Public domain; "The Fire of Troops," from *Frank Leslie's Illustrated Newspaper*, June 29, 1861, page 97. *Courtesy Missouri History Museum, St. Louis. P0084-1317: Civil War Collection, Photographs and Prints Collection*; "The St. Louis Cotton Club Band." *Missouri History Museum, St. Louis. Photographs and Prints Collection, N27534, Block Brothers Studio Collection.*

First published 2017

Manufactured in the United States

ISBN 9781467136839

Library of Congress Control Number: 2016948315

*To John O'Connor, Jennifer Niamh, Darrell Lee and Thomas Patrick Jr.,
as well as to Jack, Cashel, Seigo, Maggie, Molly, Finn and Julia. With love.*

*M.K. and T.K.*

# CONTENTS

# ACKNOWLEDGEMENTS

I am grateful to the many people who made this book possible. First and foremost, I want to thank my husband, Tom Kavanaugh, for taking so many of the photographs, for his beautiful work as photo editor, for his assistance in formatting the manuscript and for his never-ending love and encouragement. I couldn't have made this book without him.

Thanks to my son, John Kavanaugh, for proofreading my manuscript and for his insightful recommendations and to St. Louis historians and friends Mary Seematter and Kathy Petersen for carefully reading over the text and making excellent suggestions.

I appreciate the assistance of all who helped me with image permissions and acquisitions: Tad Bennicoff of the Smithsonian Institution Archives; Dennis Northcott of the Missouri Historical Society Library in St. Louis; Andy Hahn, director of the Campbell House Museum; Bob Moore Jr. and Doug Harding of the Jefferson National Expansion Memorial; Charles E. Brown of the Mercantile Library of St. Louis; Kevin Murray, manager of the Drury Plaza Hotel in St. Louis, as well as Carolyn Feltner of the Drury Development Corporation; Professor Fred Fausz of the University of Missouri–St. Louis; Stephanie Bliss, assistant director of the Eugene Field House Museum; Tess Pruett of the Hampson Museum State Park, Wilson, Arkansas; artist Herb Roe; Michael Schoenewies, Jessi Schoenewies, Craig Williams and Susie Jansen of CAIRN (Cave Archaeology Investigation and Research Network); and, in particular, Jaime Bourassa of the Missouri History Museum Library for devoting so much time to finding the images I needed, up to the very last minute.

I want to thank very specially pastor Monsignor Jerome Billing and associate pastor Reverend Richard Quirk of the Basilica of St. Louis, King of France (the Old Cathedral), and Rick Erwin, director of City Museum, for giving me permission to photograph parts of their cathedral and museums.

My thanks to Adele Heagney for her kind assistance in locating references for my research at the St. Louis Public Library and to Toni Massucci Kuhlman for sharing her wonderful memories of Café Louie and her dad, Jimmy Massucci.

For their encouragement of my work in researching and telling St. Louis history over many years, I am grateful to Mary Seematter of the Carondelet Historical Society, Joe Winkler of the St. Louis Public Library, Michelle Swatek of the American Institute of Architects, Joellen Gamp McDonald of the Richmond Heights Historical Society, Andrew Weil and Ruth Keenoy of the Landmarks Association of St. Louis, author and master teacher Marty Hoessle of the Community School and Andy Hahn of Campbell House.

Thanks, too, to my dear older brother, Michael O'Connor, who has nurtured my interest in St. Louis history with many wonderful books over the years.

I would like to acknowledge nine St. Louis historians whose splendid work I reread often and whom I reference widely in this book and regularly recommend while giving tours; their contributions to my understanding of St. Louis have been profound: Frederick Billon; Charles Peterson; William Barnaby Faherty, SJ; John Francis McDermott; Louis Gerteis; Frederick Hodes; William Winter; Fred Fausz; and John Wright Sr.

Finally, I want to thank The History Press; my commissioning editor, Ben Gibson, for entrusting this book to me; and Ryan Finn, production editor, for his keen attention to detail and guidance. It's been quite an adventure.

Introduction

# Forward (and Backward)

The lay of the land makes it just possible to stand at the southeastern edge of the Jefferson National Expansion Memorial Park (the Arch Park) near Poplar Street and be able to visualize ancient downtown St. Louis in relation to its modern counterpart and the wider Mississippi Valley.

The first orthotropic bridge in the United States, engineered by Sverdrup & Parcel, sweeps away immediately to your right with an almost constant flow of heavy traffic. It's known locally as the Poplar Street Bridge.

Directly behind you, skyscrapers and the ruddy face of Busch Stadium (home to baseball's St. Louis Cardinals) mark the city's southern skyline, while a newly sculpted park space covering what remains of the first two natural limestone terraces that front the Mississippi at St. Louis, shaped by glaciers and a great sea in an earlier age, sweeps northward.

In the near distance to your left, you can see St. Louisan James Eads's magnificent, triple-arched bridge spanning the Mississippi, the first primarily steel bridge in the world and one of the great engineering feats of the nineteenth century.

Below you, on the mighty Mississippi, there is a continual stream of tugboats, barges, excursion boats and the occasional riverboat heading north to Minneapolis or south to Memphis or New Orleans.

But if you had stood in this very spot in about the year 1000, the view would be very different except for the great river. You would find yourself in the heart of ancient North America and see the Mississippi and its valley teeming with thousands of the mysterious people who built the first

metropolis north of Mexico and were going about their daily lives on both sides of the river.

You'd be standing at the edge of a thickly wooded bluff. Directly behind you, the land continues to rise to the top of a third terrace that reaches westward in rolling prairie, while across the Mississippi, the lowland of the Great American Bottom is dotted with curious earthen mounds of varying shapes and sizes that stretch east and north to the horizon line as far as you can see.

Turning to your left on this side of the Mississippi, you can see another succession of mounds in the distance, beyond timber houses with grass roofs. One of them stands head and shoulders above the others, with a timber structure on its level top.

If you turn to the right, you can barely make out in the distance a conical mound, strategically perched atop a river bluff like a lookout. Small and large river craft move along the Mississippi's rapid current below you, transporting trade goods from the north and the south.

Downtown St. Louis is today the historic and cultural heart of the St. Louis metropolitan area. Established as a French fur trading post in 1764 by Pierre Laclede Liguest, entrepreneur and former soldier of France, long after the Mississippian culture had disappeared, it would evolve into the Gateway to the West.

This book covers approximately a one-thousand-year period and a geographic area primarily bounded by the Mississippi River on the east, Jefferson Avenue on the west, Chouteau Avenue a little south of the Poplar Street Bridge and roughly Carr Street on the north. The focus of this hidden history is downtown St. Louis, where in the vicinity of Poplar Street early levels of the city's civilization have come to light in the twenty-first century and fragments of our colonial and Civil War past have been revealed. Whether anything at all of the Mississippian culture still lies hidden in this area remains to be seen.

This book is an exploration of some of the highlights of hidden downtown St. Louis over the past millennium, including its inhabitants, landmarks and rich stories. It's small enough to carry around with you as you walk the area on your own or visit it virtually from the comfort of your favorite chair.

I hope that you will enjoy this journey through time and that it will pique your interest to read and explore more deeply the dramatic history of St. Louis as it has been recorded at length in the works listed in the bibliography of this book.

# Chapter 1
# THE MOUND CITY

Sometime between the years AD 1050 and 1400, an amazing culture with deep roots in Louisiana—and, later, the Ohio and Tennessee River Valleys—reached its zenith on the fertile, alluvial floodplain of the mid–Mississippi River Valley, at the present site of Cahokia Mounds,[1] Illinois, across the river just north and east of downtown St. Louis. Sometime during that same period, its people also constructed a mounded, sister city above the labyrinth of caves on this, the west bank of the Mississippi, that would give St. Louis an early nickname, the "Mound City."

These people—who came to be known as Mississippians for the great river along which they raised thousands of earthen mounds from the Gulf of Mexico to the Great Lakes—built the largest pre-Colombian earthwork in the Americas. It was a huge, truncated pyramid, rectangular in shape[2] and approximately one thousand feet long and seven hundred feet wide, rising in four terraces to a height of one hundred feet. A platform mound with a wooden temple at its summit overlooked the ceremonial plaza of their capital and the first city north of Mexico.[3]

Today Monk's Mound is preserved with roughly another 79 of the possible 109 to 120 earthworks that once covered a six-mile area centered at the Cahokia Mounds site (later named for an Illini tribal nation residing in the area). Time and weather have altered the original sizes and caused the once sharply delineated edges of many to slump, but a remarkable number survive as reminders of the people who ruled the Mississippian kingdom from the mid–Mississippi River Valley for several hundred years.

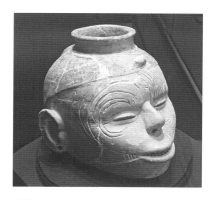

Effigy Pot of the Mississippian Culture. *Courtesy of the photographer, Herb Roe, and the Hampson Archaeological Museum State Park, Wilson, Arkansas.*

What we know of the Mississippians comes primarily from the decades-long archaeological work carried on at Cahokia Mounds, Illinois, and from much broader excavation and research in the area of the lower Mississippi River and its tributaries.

Mississippians buried their royal dead in aboveground earthen mounds that were often conical in shape. They constructed platform mounds leveled at the top for the homes of their chieftains and still higher temple mounds. At Cahokia, they also built wooden enclosures for defense and wood henges to mark the movement of the sun.[4]

Although their language is lost to us, and no evidence of a written language has been found, artistic symbols that illustrate a reverence for the sun and other elements of nature survive. At the height of their culture, they were an agrarian people who harvested enormous quantities of corn, beans and squash. There is also evidence to suggest that they practiced human sacrifice.

These Mississippians hunted game and fished the rivers along which they settled, trading with other Native Americans over a vast area—from the Great Lakes in the North to the Gulf of Mexico in the South and from the Appalachian Mountains in the East to the Great Plains and Rocky Mountains in the West.

During the Medieval Warm Period (MWP), they moved into the mid–Mississippi River Valley and perfected a method of clay construction distinguished by the use of ground mussel shells to produce thinly shaped walls that were watertight. Among their artisans were highly skilled metalworkers who sculpted and incised images of them and their spirit gods onto jewelry even as their potters did in clay. These Mississippians were the first known architects of the Greater St. Louis landscape.

In 1673, Jesuit missionary Jacques Marquette and explorer Louis Joliet drew a map of the upper Mississippi River where it intersects the Grand River, identifying numerous tribal people whom they encountered on their banks. On this map they sketched several earthen mounds that they observed along the rivers.

But it's Vincenzo Coronelli's *1688 Map of Western New France, including the Illinois Country* that illustrates how St. Louis gained the early nickname of Mound City. If you follow the line of the Mississippi south to near the bottom of Coronelli's map, you will see just below its confluence with the Missouri River a widened area of mounds that encircle the river. They are but a suggestion of the more than one hundred man-made, mountain- and hill-like structures that dotted this area.

There is no record of the French and Creole founders of St. Louis disturbing or leveling the earthworks on the west bank of the river, but later settlers would build on them and eventually demolish all but Sugar Loaf Mound, south of downtown St. Louis. Had it not been for a happy accident of fate, there would be no visual record or scientific survey of the "Ancient Mounds at St. Louis, Missouri," as T.R. (Titian Ramsey) Peale, chief examiner of the United States Patent Office, named them when he published the map he had made with Thomas Say in 1819.[5]

Peale and Say were young officers on an exploratory expedition under the command of Major Stephen Long of the U.S. Topographical Engineers, headed for the upper Missouri River and the Rocky Mountains, when their

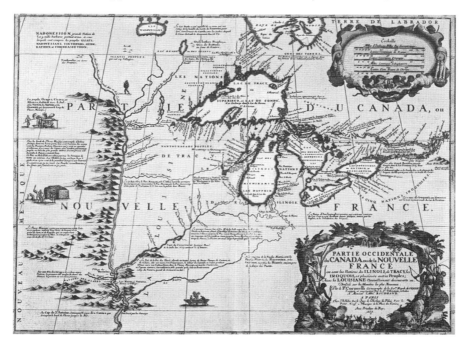

*Map of Western New France, including the Illinois Country*, by Vincenzo Coronelli, published in 1688. *From the National Archives in Canada.*

steamer, the *Western Engineer*, had an accident; they needed to return to St. Louis for repairs. The "ancient mounds just above the town" captured their interest, and with time on their hands, Titian Peale and Thomas Say surveyed the St. Louis Mound Group shown. Within about fifty years, all of them would be erased from the St. Louis landscape.

In 1861, Peale came upon his beautifully drawn map in an old portfolio and offered it to the Smithsonian, which promptly published it along with the measurements and description of twenty-seven structures. Numbered from 1 through 27, they represent the remains of the bastion of St. Louis's old Spanish stockade and all or parts of twenty-six mounds: shape, height, length of longitudinal and transverse bases, distance from one to another and, in the case of Mound 2, distance from the bastion of the Spanish stockade.[6]

They also indicated the distance of the mounds from the edge of the bluff, all of them having been constructed on the second terrace facing the Mississippi, and numerous mounds directly across the river, as well as Cahokia to the northeast. The bases of the mounds ranged in shape from squares to oblong squares, nearly square, irregular, parallelogramic, quadrangular and elongated-oval, with tops that were conical, convex or flattened. There were also two small barrows. Some bases were as short as 25 feet, while the longest was 319 feet. They ranged in height from 4 feet to approximately 34 feet. Two of these mounds were especially distinctive: Mound 6 for its shape and Mound 27 for its size.

Mound 6, a three-tiered parallelogram, was in colonial times perhaps the most picturesque of the St. Louis Mounds, for the French called it Falling Garden. In spring, summer and autumn, wildflowers and blooming vines would have cascaded down its steep, obliquely sculpted slope.

The earliest St. Louisans did not dislodge these mounds, but they did name them and used them as boundaries, and as landmarks, to gauge their relation from the river to the bluffs and the town, as would later steamboat pilots—the Mississippi River, with its circuitous bends and rough shoals, could be treacherous to navigate.

*La Grange de Terre* (the Barn of Earth) was, at approximately thirty-four feet, the second-tallest Mississippian Mound in this area, although it stood distant from its neighbors. Thomas Say described it in 1819 as "an elongated-oval form, with a large step on its eastern side...1,463 feet north of Mound 26."

During the nineteenth century, artists Maria von Phul and John Casper Wild made paintings of Mound 27, and photographer Thomas Easterly later produced a series of daguerreotypes recording its demolition. But

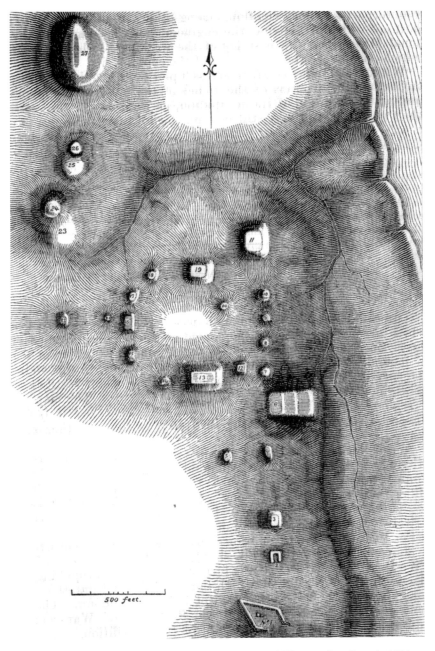

*The Ancient Mounds at St. Louis in 1819*, by T.R. Peale and Thomas Say. *From the* 1861 Annual Report of the Board of Regents of the Smithsonian Institution, *page 387.*

T.R. Peale's map remains the only known image of the entire downtown St. Louis Mound Group.

Just one year earlier, in 1818, Kentuckian Maria von Phul, an enterprising and adventurous young painter visiting family in St. Louis, rendered in watercolor what English-speaking St. Louisans called the "Big Mound." It reveals that bushes and small trees had taken root in the earthwork along with prairie grasses. She then climbed *La Grange de Terre* and painted the view from the top—the Mississippi River below and earthen mounds on its eastern bank.

J.C. Wild was a Swiss artist who came to the United States in 1832 and made a remarkable record of the Mississippi Valley in paintings and colored lithographs. His 1840 *Northeast View of St. Louis from the Illinois Shore* shows the scale of the Big Mound in comparison to the buildings around it. Wild clearly positioned himself far enough away from the mound to give a clear perspective of its relation to the Mississippi River and the bluff on which it stood. His painting illustrates what a remarkable landmark it was.

Today, a boulder with an engraved plate situated in a newly created park at North Broadway and Mound Street, in proximity to the Stan Musial Veterans' Memorial Bridge, marks the approximate site of the Big Mound.

Thomas Easterly's daguerreotype of the Big Mound, shortly before it was completely demolished for construction of a railroad line in 1869, shows the tremendous scale of the earthwork in proportion to the people standing on and around it. But at a mere thirty-four feet, it would have been dwarfed by its predecessor, Cahokia's ten-story-high Monk's Mound.

Archaeological excavation at the time of the Big Mound's demise revealed that it contained four separate strata of soil and that its height had been increased over time. The large burial chamber at its base, which had collapsed, housed the skeletal remains of several individuals, who were buried facing west, along with river mussel shells, seashells from the Gulf of Mexico and copper ornaments.[7] Archaeologists believe that during the Mississippian era, Monk's Mound in Cahokia would have been visible from the Big Mound in St. Louis and that fires burning from their summits would have allowed for smoke signals to carry messages over a distance of several miles.

What became the expanded city of St. Louis contained many more Mississippian earthworks, some of them very large, mostly constructed in proximity to the river but some more than a mile distant from its banks. All of those mounds were demolished or significantly altered except for Sugar Loaf Mound south of downtown. The top was leveled and modest

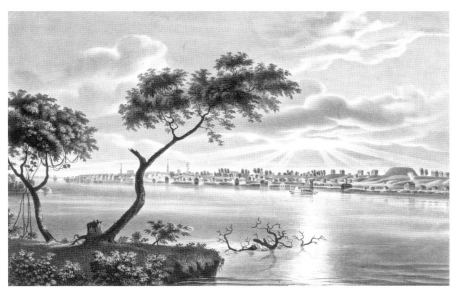

*Northeast View of St. Louis from the Illinois Shore*, by John Casper Wild, 1840. *From the J.C. Wild Lithographs Collection. Missouri History Museum, St. Louis.*

homes built on the summit and second step during the late nineteenth and early twentieth centuries, and a landfill conceals its southern base. This sweeping, three-step structure, which originally ended in a conical mound with a steep southern slope, is a striking example of Mississippian architecture and craftsmanship.

Dated to about AD 1000, Sugar Loaf Mound is the last known vestige of the Mound City, the sole extant work of the first known architects of the St. Louis landscape. Like the ancient mounds that survived in the northern part of downtown St. Louis into the early nineteenth century, it was constructed over a cave, an entry to a spiritual underworld.

Sugar Loaf (*Pain de Sucre* to the French) has never been completely excavated and likely won't be. The Osage Nation, which now owns it, regards Sugar Loaf as an ancestral burial site. When St. Louis was founded, the Osage were one of the most powerful tribal nations in the mid–Mississippi Valley. Their descendants are planning to restore it as a heritage and interpretive site.

Although graded very differently, Sugar Loaf is a three-step mound, as was Falling Garden. A fascinating thirty-minute documentary, *Uncovering Ancient St. Louis*, written and produced by Mark Leach in 2009, describes recent archaeological and geological research being done into Mississippian

Culture on this, the west side of the river.[8] In it, archaeologists suggest that such three-tiered mounds may have related to a Mississippian cosmology that encompassed a three-tiered world—underworld of caves, middle world of earth and water and sky world into which tall mounds reached. They also pose a theory that ancient St. Louis, honeycombed as it was with caves, was an ideal site over which to erect mounds, possibly a "sacred sister city of the moon in the west, corresponding to Cahokia, sacred city of the sun in the east."[9]

A *Journal of American Science*, published in 1882, reported that French explorers had found two human footprints on the downtown St. Louis riverfront "made into rock when the earth was still soft." In 1763, while scouting out a location for a trading post, St. Louis founder Pierre Laclede and co-founder, Laclede's young stepson, Auguste Chouteau, noticed those ancient footprints.

Directly below the downtown St. Louis Mound Group, Mississippians sculpted terraces out of the limestone bluff and created a stairway that led from the edge of the river up to the mound complex, suggesting a place of powerful ritualistic ceremony and significance. But it appears that sometime between 1350 and 1400, Cahokia and its sister city at present-day St. Louis were abandoned. Precisely what became of the Mississippian Mound People is unknown. The Late Mississippian Era (circa 1450–1540) was a time of growing political conflict and warfare, within and between neighboring chiefdoms.

The increasingly mild climate, which had been so conducive to the rise of their culture—allowing it to spread from Louisiana into Mississippi, Alabama, Georgia, Kentucky, Arkansas, Ohio, Indiana, Missouri, Illinois, parts of Wisconsin and Minnesota—ended with the colder temperatures and shorter growing periods of the Little Ice Age (circa 1300–1850).

Warfare, drought and a shortage of food resulting, in part, from the overplanting, overhunting and deforestation of the areas of their large towns and villages may have led the Mississippians who survived to disperse and meld with or evolve into other Native American groups.

Father Jacques Marquette described and made a sketch of two remarkable pictographs that he saw on the bluffs along the Illinois River east of St. Louis that were later dated to about the year 1200. They are considered to be Mississippian artwork that relates to a mythical creature found in earlier Mississippian art:

*While Skirting some rocks, which by Their height and length inspired awe, We saw upon one of them two painted monsters which at first made Us afraid, and upon Which the boldest savages dare not Long rest their eyes. They are as large As a calf; they have Horns on their heads Like those of a deer, a horrible look, red eyes, a beard Like a tiger's, a face somewhat like a man's, a body Covered with scales, and so Long A tail that it winds all around the Body, passing above the head and going back between the legs, ending in a Fish's tail. Green, red, and black are the three Colors composing the Picture.*[10]

Another aspect of Mississippian culture survived well into the early nineteenth century, as American artist George Catlin painted Mandan braves playing a game of Tchung-kee in 1832:

*The game of Tchung-kee [is] a beautiful athletic exercise, which the Mandan seem to be almost unceasingly practicing whilst the weather is fair, and they have nothing else of moment to demand their attention. This game is decidedly their favourite amusement, and is played near to the village on a pavement of clay, which has been used for that purpose until it has become as smooth and hard as a floor....The play commences with two (one from each party), who start off upon a trot, abreast of each other, and one of them rolls in advance of them, on the pavement, a little ring of two or three inches in diameter, cut out of a stone; and each one follows it up with his "tchung-kee" (a stick of six feet in length, with little bits of leather projecting from its sides of an inch or more in length), which he throws before him as he runs, sliding it along upon the ground after the ring, endeavouring to place it in such a position when it stops, that the ring may fall upon it, and receive one of the little projections of leather through it.*[11]

There's evidence to suggest that Tchung-kee may have originated in the Cahokia area in about the year AD 600.[12] If so, it well may be that it was played in what became downtown St. Louis, where baseball and hockey reign today, although any physical evidence of that remains hidden.

# Chapter 2

# EARLY MISSOURI TRIBES
# AND FIRST NATIONS

As the Mississippian era drew to an end, many tribes and nations migrated into what would become the state of Missouri—from the north and northeast the Missouria (driven from their villages by Iroquois), as well as their Otoe and Iowa cousins, and from the east and southeast the Illinois, Osage, Chickasaw and Quapaw.[13]

The state of Missouri, like the state of Illinois and twenty-two other states, adopted its name from early tribal communities that lived within its boundaries. In some cases, the pronunciation and recording of these names was as close as those who spoke a different language, like French, could get to them. The Illini, an Algonquian nation, called themselves "Hileni" or "Illiniwek" ("men"), which the French interpreted as "Illinois."

In some cases, the names that became attached to certain tribes were those by which other tribes called them as opposed to what they called themselves. French missionary Jacques Marquette was one of the first explorers to record names and descriptions of the indigenous people who lived alongside the Great Lakes and in what is today the state of Missouri. Among these were the Missouria or Missouri (French adaptation of a Siouan word meaning "One Who Has Dugout Canoes").[14]

However, the Missouri called themselves Nutachi or Niuachi ("People of the River Mouth"),[15] which is precisely what they were, for Marquette and fellow explorer, trader Louis Joliet, found them living at the mouth of the Missouri River in 1673.[16] Nutachi oral history tells of their ancestors having once lived north of the Great Lakes before migrating south during

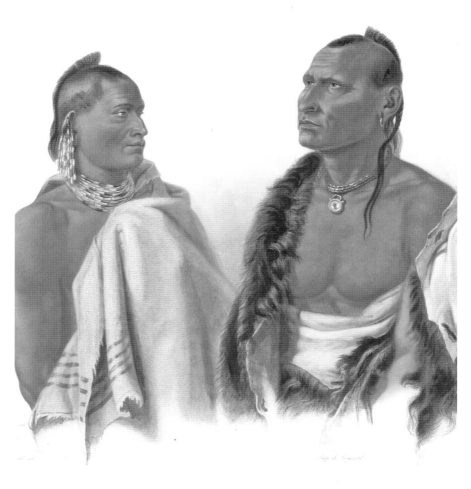

MISSOURI INDIANER.

Indien Missouri

MISSOURI INDIAN

OTO INDIANER.

Indien Oto

OTO INDIAN

*Missouria, Otoe, Ponca Indians*, by Karl Bodmer (detail, showing members of the Missouria and Otoe tribes only).

the sixteenth century. By 1600, they lived near the confluence of the Grand and Missouri Rivers in the northern part of the state. During the eighteenth century, their numbers were greatly diminished by tribal warfare and smallpox. Until the nineteenth century, the Missouri, like the Otoe and Iowa, were primarily hunter-gatherers.

Like other Native Americans, they established villages near fresh bodies of water such as lakes and rivers. Although many took their tribal names from places where they established villages, they were often forced to move because of the encroachment of other tribes. Their communities were based on kinship, shared language, spiritual beliefs and customs. They established alliances with other tribes for defense and for trade. It was into this milieu—a great diversity of languages and long-established culture—that Europeans came.

In *Before Lewis and Clark: The Chouteaus*, historian Shirley Christian related that even as the trading post that became St. Louis was still under construction in 1764, four hundred Missouria, having made a journey of 180 miles from their village, visited the site, wanting to relocate here. Although they did not stay, in a symbolic foreshadowing of the trade that would so mark *La Poste de Saint Louis*, Missouri women and children dug the foundation for the fur trading post in exchange for vermilion, verdigris and awls.[17]

Illini tribes, once numbering as many as twelve and later reduced to five (Cahokia, Kaskaskia, Peoria, Tamaroa and Michegamea), dwelled and ranged for hunting over a wide area between the Mississippi and Ohio River Valleys and as far north as Lake Michigan.[18] The men were hunters and warriors. The women did most of the village labor. Illini braves were polygamous, but if a woman were unfaithful to her husband, she suffered mutilation. Historian Frederick Hodes has suggested that Illini tribes once inhabited and controlled all of what would become the metropolitan St. Louis area on both sides of the Mississippi River (including downtown St. Louis).[19]

Soon after he arrived in Canada, Father Jacques Marquette learned to speak the Algonquian language so that he could communicate with the people. He described an early encounter with the Illini in northern Missouri:

*At the Door of the Cabin in which we were to be received was an old man, who awaited us in a rather surprising attitude, which constitutes a part of the Ceremonial that they observe when they receive Strangers. This man stood erect, and stark naked, with his hands extended and lifted toward the sun, As if he wished to protect himself from its rays, which nevertheless shone upon his face through his fingers. When we came near him, he paid us This Compliment: "How beautiful the sun is, O frenchman, when thou comest to visit us! All our village awaits thee, and thou shalt enter all our Cabins in peace." Having said this, he made us enter his own, in which were a crowd of people; they devoured us with their eyes, but, nevertheless,*

*observed profound silence. We could, however, hear these words, which were addressed to us from time to time in a low voice: "How good it is, My brothers, that you should visit us."*[20]

The Illini welcomed Marquette and Joliet, sharing with them a peace pipe and a large meal, and told them how they might make their way to the great sea for which they were looking.

Another early Missouri tribe, Quapaw (Ugahxpa—O-gah-pah) migrated into southeastern Missouri in the seventeenth century, making their home in and around the boot heel area, just west of the Chickasaw. Known by other tribes as Akanasea or Akansa, theirs was "the land of the down river people."[21] They would give their name to the state of Arkansas.

The Chickasaw (*Chikashsha*, meaning "rebel") also inhabited southeastern Missouri when they were trading at St. Louis. But they had an oral tradition of once having lived west of the great river (the Mississippi) before settling in the east and, much later, moving west again. One of their creation stories tells of their ancestors having emerged from a sacred mound.

Before the arrival of Europeans, more than five hundred tribal groups peopled the continental United States. There were no state boundaries or

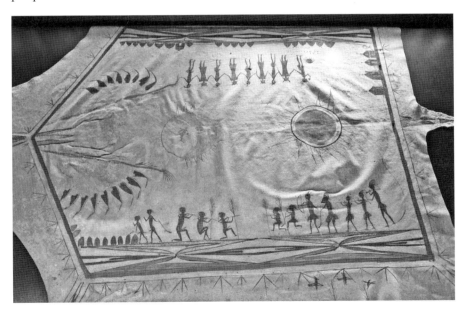

Painted deerskin "Three Villages Robe" of the Qwapa/Akansas People, made in the eighteenth century. *From the Musee du quay Branly.*

*Iowa Indians in London & Paris*, by George Catlin. *From the National Gallery of Art.*

mapped delineations between them. The territorial distinctions between their ancestral lands were fluid and the inland waterways their highways.

Below the Missouria and west of the Illinois and Quapaw dwelled the mighty Osage nation amid the beautiful Ozark Mountains and along a river that still bears their name, the Osage River. Their sages sang their histories in words that were powerful and imagistic, drawing their spirituality from nature and the world about them. Their words became sacred repositories for ancestors, traditions and wisdom, as here from "The Osage Story of Creation":

> *Into the Earth my grandfathers dug,*
> *In the palm of their hands they rubbed its soil.*
> *Into the Sacred One, the Aged One they dug;*
> *In the palm of their hands they rubbed its soil.*
> *Into the Earth my grandfathers dug;*
> *Upon their foreheads they put its soil.*[22]

By the mid-1760s, when Pierre Laclede situated his fur trading post on the first elevated site below the confluence of the Mississippi and Missouri Rivers, the Osage controlled large areas of what became Missouri, Arkansas, Oklahoma and Kansas.

These Wah-Zah-Zhi (pronounced "wah-sha-she"), People of the Middle Waters, established hunting and trade routes far beyond their villages, from what became St. Louis west and south to Santa Fe, New Mexico. Laclede and his New Orleans business partners were anxious to establish exclusive trade relations with them. In time, their ancestral route would become the heavily traveled Santa Fe Trail.

The oral tradition of the Osage and other Dhegiha Sioux (Kaw, Omaha, Ponca and Quapaw) recounts Indian Knoll near the mouth of the Green River in Kentucky as their ancestral home. In paleolithic times, they ranged from the fork of the Ohio River to the Mississippi and beyond. Once peace-loving, the Osage became warlike in the face of invasion by the Iroquois,

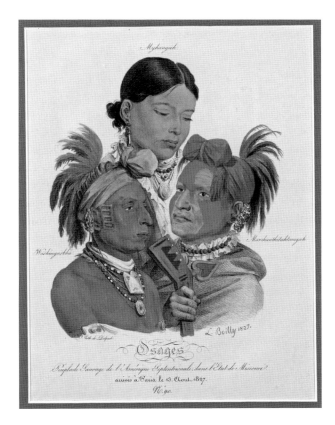

Osages, Myhangah, Washingasbha and Marchar-kitah-toonha, by Louis-Leopold Boilly. From the collection of Fred and Jeanette Fausz of Florissant, Missouri.

who had dominated much of the Northeast. By AD 1200, both the Osage and the invading Iroquois had left Kentucky.[23]

The Osage Bear Clan story of creation has "the Four Winds gathering all of the flood waters on earth and draining them into great rivers at a place they called Ni-U-Kon-Ska (The Middle Waters); today the junction of the Missouri, Mississippi, Ohio, Tennessee, Wabash, Arkansas, and Illinois rivers." Here they settled in great numbers, dividing themselves into diverse bands and clans, into Earth People and Sky People.[24]

In 2014, Osage principal chief Scott Big Horse delineated some of the family ties between the Osage and French in early St. Louis, including the Chatillon and DeMenil families, as well as the impact his nation had on the founding and rise of St. Louis. Over time Caddo, Dakota, Delaware, Fox, Kickapoo, Omaha, Sauk and Shawnee also inhabited Missouri. Records dating to Spanish colonial St. Louis indicate that in 1777, nineteen tribes—including Little and Greater Osage, Missouri, Kansas, Iowa and Winnebago (for whom present city streets are named)—came to trade in what is today downtown St. Louis.[25]

During the celebration of the 250th anniversary of the city's founding in 2014, an honorary street sign was added to the northeast corner of Broadway and Pine Street in downtown St. Louis bearing the name *La Rue Quicapou*. It commemorates the Kickapoo tribe, who once resided in Missouri and traded in downtown St. Louis. But Chestnut Street has long since replaced *La Rue Missouri*, the road directly south of *La Rue Quicapou*.

From 1764 onward for many years, the Missouri and Osage were regular visitors, with the Missouri arriving in dugout canoes with tipis that they set up along the banks of Chouteau's Pond. Drained in about 1850, the former pond is today the site of the rail yards in downtown St. Louis.

# Chapter 3

# ENLIGHTENED FRENCHMAN
# IN THE HEART OF ANCIENT AMERICA

A somewhat idealized bronze sculpture of city founder Pierre Laclede
Liguest stands within a rose garden in the southwest corner of
Washington Square Park, adjacent to city hall in downtown St. Louis. The
work of Hungarian artist George Julian Zolnay, it depicts Laclede stepping
ashore at the site he chose in 1763 for the trading post he would later name
for King Louis IX of France. That site would become the foot of Market
Street (originally *La Rue de la Place*). When the downtown St. Louis riverfront
was turned into a national park, the east end of Market Street became the
south side of the Arch staircase.

However, to this day, Laclede's street plan continues north, south and
west of the Jefferson National Expansion Memorial Park for many blocks.
This grid plan did not originate with Laclede. New Orleans, where he
lived for about seven years, was laid out in a similar plan, with its roots in
medieval Europe.

Laclede's statue at city hall is idealized in its heroic proportions and
approximate in the sense that Zolnay had for a model the only life-size
rendering known to exist of someone who had resembled Laclede in life: a
statue made of his grandson Pierre Chouteau Jr. for the Louisiana Purchase
Exposition of 1904.

For much of the past 250 years, the former French soldier who established
St. Louis in 1764 remained shrouded in mystery, and the impact Laclede
had on the culture and the entrepreneurial spirit of St. Louis, which was
deep and lasting, remained largely unrealized. Zolnay's sculpture captures

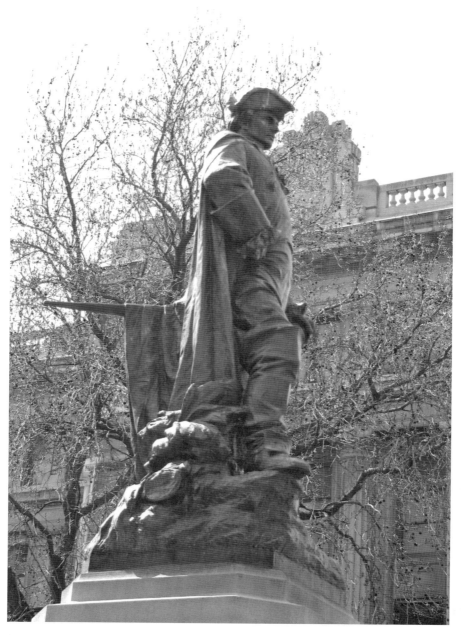

Statue of St. Louis founder Pierre Laclede de Liguest, northwest corner of city hall, by George Julian Zolnay. *Thomas P. Kavanaugh, ed.*

the intelligence and daring of the thirty-four-year-old Frenchman who left New Orleans to establish trade in the mid–Mississippi River Valley with Native Americans, as French fur traders had been doing out of Canada along the upper Mississippi and Great Lakes for nearly a century.

That Laclede regarded American Indians as human beings with whom he could establish business ties as well as friendships appears to have been a given. Schooled by Jesuits[26] and a reader of Rousseau and Voltaire (who was a family friend), Laclede brought an enlightened European sensibility to Native American relations that characterized St. Louis for decades.

Zolnay's sculpture of Laclede also captures the determination and military bearing for which he was known in his lifetime, but it doesn't convey his true height (about five feet, nine inches), olive complexion or the dark, piercing eyes that perceived so much of topography and character and for which he was also remembered.

Pierre Laclede de Liguest was born on November 22, 1729, the fourth of seven children, to Magdeleine d'Espoey and Pierre de Laclede Sr. in Bedous, France, a village in the foothills of the French Pyrenees. "Liguest" was added to his family name to distinguish his name from his father's.[27]

Laclede learned Latin as a boy and French as a second language, for his first language was Occitan, the dialect spoken by the fiercely independent people of the Bernais area of southern France.[28] The precious library of close to two hundred volumes that Laclede brought with him to the Illinois country included subjects as diverse as accounting, medicine, animal husbandry, gardening, history, philosophy, science and the arts. Among the many books was Miguel de Cervantes's *Don Quixote* in Spanish.[29] Growing up so close to the Spanish border and patrolling the mountains as a young soldier, Laclede must have understood Spanish.

In his early teens, Pierre Laclede went to boarding school at the Jesuit College in the nearby city of Pau, the capital of Bernais. There he received a classical education and may have developed an interest in philosophy (suggested by several of the books he owned) and quite possibly an interest in North America and the tribal people about whom Jesuit missionaries like Father Marquette had so powerfully written.[30]

Growing up in Bedous, Laclede witnessed the tremendous power of the Aspe, the gentle river that swelled to a torrent when the winter snows melted.[31] Making his way north from New Orleans eventually to the Mississippi's confluence with the Missouri, against the current, he would come to realize that his choice of a site for a fur trading post would need to be situated along, but safely above, the mighty Mississippi River. The Mississippi merges

with the Missouri to form the fourth-largest river system on Earth, draining thirty-one of the continental United States and two Canadian provinces. It, too, can become a torrent.

Laclede finished his education at the Military Academy in Toulouse, where he was awarded a silver-hilted, elaborately engraved sword for his skill at fencing that he carried with him to North America.[32] Engraved with the coat of arms of Louis XV of France, it no doubt caught the eye and garnered the respect of many American chieftains—like them, Laclede had clearly been trained as a warrior and was prepared to defend himself and his people.

Shortly after arriving in New Orleans, Pierre Laclede met and fell in love with a very resourceful young Creole woman of French descent, Marie Bourgeois Chouteau, whose husband, René, had abandoned her and their young son, Auguste, some years before. Marie Chouteau considered herself a widow, but she couldn't legally prove it. She and Laclede entered into a common-law marriage that lasted more than twenty years until his death. They had four children together, a son and three daughters, all of whom were christened with the family name Chouteau. That Laclede had actually been their father was for decades one of the greatest secrets in St. Louis history.

Laclede's statue beside St. Louis City Hall (modeled on the Paris City Hall) conveys much of the man he was. But you get a more powerful sense of Laclede's imprint on St. Louis if you look at a map of the downtown street grid, which is a direct continuation of the plan that he drew up in 1764 and gave to his fourteen-year-old stepson, Auguste Chouteau, whom he had mentored from early childhood and to whom he entrusted the actual construction of the trading post, to follow. Auguste accomplished his assignment with such proficiency that he is considered to be the co-founder of St. Louis. In time, he would become its leading citizen.[33]

Laclede spent a little less than fourteen years in what became St. Louis, from December 1763, when he chose the site, until his death near Arkansas Post in 1778. Yet the decidedly French community he founded here on the west bluffs of the Mississippi River would remain French even after Spain officially took governance of it in 1770,[34] through the 1820s, when American settlers began outnumbering the French and Creoles of St. Louis and their many descendants.

The city's first historian, Frederic L. Billon, recorded in the *Annals of St. Louis in Its Early Days Under the French and Spanish Dominations* that "the few Spaniards who settled in the country soon became Frenchmen, and all

married French wives."[35] He also noted that by 1766, French colonial St. Louisans had established "a self-instituted government by the people of the place." Virtually every issue, from "acting-governor" to where and of what dimensions a trench for water runoff was to be constructed, was decided by consensus.[36] This was ten years before the American colonies' Declaration of Independence and twenty-three years before the French Revolution.

A 1790s map titled *Plan of St. Lewis* illustrates that Laclede's map of the village had changed little since 1764. But over the next two hundred years, a sprawling residential and commercial river metropolis would grow up on the original city blocks until, by 1875, St. Louis would be unrecognizable as a French colonial outpost.

An aerial photograph taken of the downtown St. Louis riverfront in 1942, after it was cleared for a national park, revealed that while Laclede's original vision for *La Poste de Saint Louis* had been hidden, it had never been lost. One of a very few remaining structures in that photograph is the Old Cathedral.

The Basilica of St. Louis, King of France, is shown with its steeple on the upper-left side of Camille Dry's illustration of the levee in St. Louis in 1875. A tiny numeral "1" identifies it. The oldest man-made structure on the downtown riverfront today, it was left standing in the original church

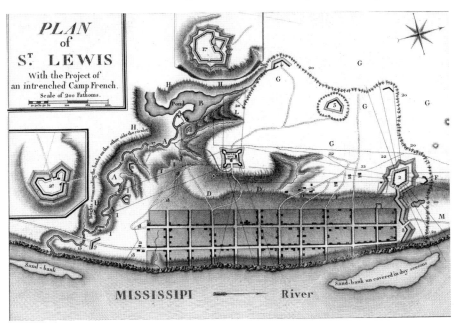

*Plan of St. Lewis*, 1790s. *Courtesy of the Missouri History Museum, St. Louis. N35958: Map Collection.*

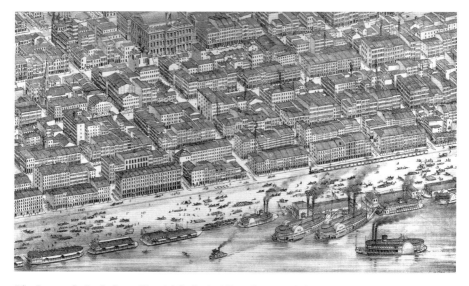

*The Levee at St. Louis*, from *Pictorial St. Louis*, 1875. *Courtesy of the Missouri History Museum Library, St. Louis. N28881: Plate 1.*

block designated by Laclede in 1764, on the only piece of land in St. Louis that has never been bought or sold.

Among the early characteristics of French colonial St. Louis that survive are a relaxed hospitality and a "live and let live" philosophy that distinguished what began as a very ethnically, racially and socioeconomically diverse community.

From the French and Creole culture, we also get Carnival Season. It begins at Epiphany (January 6) and continues until Shrove Tuesday, the day before Lent, more familiarly called Mardi Gras. It's been celebrated in St. Louis from the founding of the village. St. Louis hosts the second-largest Mardi Gras celebration in the United States after the city of New Orleans, with festivities beginning in January and heating up a full week before Lent begins. While many of the events take place in the Soulard neighborhood just south of downtown, the Mayor's Benefit Costume Ball is held in city hall, and the official Fat Tuesday Parade makes its way along Washington Avenue downtown.

St. Louis was never attacked during Pierre Laclede's lifetime and only one time after. This is due, in part, to the relationship Laclede established with numerous tribes stretching as far west as the Great Plains. Nor were any of the amazing Mississippian Mounds destroyed that Laclede took note

of as he was choosing the site. Laclede's village rose up in proximity to the downtown St. Louis Mound Group but didn't interfere with it.

Whether Pierre Laclede perceived the mounds as remnants of an ancient native culture possibly sacred to the Osage and other tribal nations with whom he was working—and therefore best left undisturbed—is unrecorded but possible. In the years to come, Auguste Chouteau would recount how he and Monsieur Laclede had found what appeared to be ancient footprints along the shore and been amazed by *La Grange de Terre* (the Barn of Earth), which stood atop the river bluffs.[37] Perhaps Laclede recognized in them a sign for which he had been looking.

Chapter 4

# Colonial St. Louis
# (*La Poste de Saint Louis*)

There was no place quite like colonial St. Louis in all of what would become the United States of America. To this day, the relaxed congeniality that distinguished it from the English-speaking colonies on the East Coast pervades downtown St. Louis. But you really have to know where to look for any visual references to it because St. Louis's rich colonial history is, for the most part, hidden.

You begin to get glimpses of it within five blocks of the Mississippi River on commemorative street signs printed in French. There's a bronze plate near the front entrance of the Hilton Hotel at the Ballpark marking the site of Spanish colonial Fort San Carlos and another across the street on the southeast corner of Broadway and Walnut Street marking what is believed to be the burial site of Ottawa chief Pontiac. The latter is one of several historical markers placed downtown through an initiative by radio commentator, author and longtime St. Louis resident Charlie Brennan.

The central area of Post St. Louis/the Village of St. Louis proper was contained within the present acreage of the Jefferson National Expansion Memorial Park along the St. Louis riverfront. But with the exception of colonial artifacts displayed in the newly expanded museum in the crypt of the Old Cathedral, there is no context for it in that area until the museum beneath the Gateway Arch reopens in 2017.

Two rooms inside the Old Courthouse on Broadway between Market and Chestnut Streets are currently dedicated to colonial St. Louis. They are well worth visiting for the exhibits they contain on the city's early French

and Creole settlers; the Osage Nation, with whom St. Louisans formed such a close bond; a model of French colonial architecture prevalent in the Mississippi River Valley; a marvelous map illustrating the way St. Louis looked in 1804 as it transitioned from France to the United States of America; and a portion of the last colonial building to be taken down on the riverfront, Manuel Lisa's fur warehouse.

*La Poste de St. Louis* was a French Creole village established for trade with Native American people who visited in large numbers. It was a collaboration among settlers of different races and social ranks who were not segregated but lived alongside one another,[38] a rich jambalaya of cultures emanating from France, New Orleans, French Canada, the West Indies, Africa, North America and Spain—rustic and cosmopolitan at the same time.

Lullabies in many languages floated on the summer breeze as windows stood open to the fresh air, mixing with the aromas of ethnic recipes—gumbo, pralines, beignets (fritters), savory meat pies, apple tarts, honey-flavored corn bread and more. Those who could afford them donned silks and satins imported from France for formal and festive occasions like weddings and Carnival's Three Kings Ball, but St. Louisans generally and quickly adopted the custom of wearing Indian-made moccasins for daily comfort and warmth. For amusement, they loved dancing, making music, playing billiards and cards and racing their Indian ponies in the prairie beyond the riverfront.

The French and Creoles of St. Louis filled the wintertime with celebrations. Many St. Louisans—merchants, trappers and *voyageurs*—were involved in the fur trade and were away for months at a time, and the villagers made the most of the time they were home. A beautiful family supper was served following Midnight Mass on Christmas Eve in the little church. The first formal ball of the season took place on Christmas night.[39] The weeks before the start of Lent were marked with a round of dances, one a week, that ended with the biggest and most elaborate of all: a costume ball on Shrove Tuesday.

For at least the first four decades, the most common language spoken in St. Louis was French, and second were Indian dialects. Like Pere Marquette, who upon his arrival in Canada learned to speak and understand the Algonquian language, the merchants and *voyageurs* of St. Louis became conversant with their trading partners.

Colonial St. Louis took shape according to French law and under Laclede's leadership as neither a walled fortress nor a mission outpost but rather a community of skilled craftsmen, boatmen and merchants personally

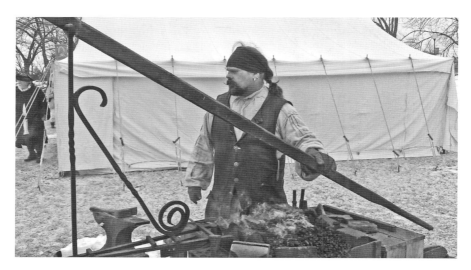

Reenactment of the founding of St. Louis at the Gateway Arch, February 14, 2014, depicting a French colonial blacksmith of the Illinois Country, Kenny Mikuleza. *Photo by Maureen Kavanaugh.*

recruited by Laclede from New Orleans and the village of New Chartres to carve out a town along the thickly forested west bluffs of the Mississippi River south of the Missouri and north of the Ohio Rivers.[40]

To his fourteen-year-old stepson, Auguste Chouteau, Laclede entrusted some very important tasks. The first involved supervising a crew of thirty men—carpenters, blacksmiths and stonemasons—as they cleared the land and began erecting a warehouse for the trade goods brought north from New Orleans presently stored at Fort Chartres and cabins for the workmen.[41] The sole access to the top of the first bluff—a single break in the sheer, four-story wall that fronted the Mississippi River—was widened into *La Rue de la Place*, and Market Street became St. Louis's first road.

Young Chouteau's second task was surveying the land, which rose in three limestone terraces along the Mississippi. The top bluff spread south, west and north in rolling prairie that would be set aside for communal growing fields and pastures.

Thirdly, he platted two (later a third) long north–south roads that ran parallel to the river and several east–west cross streets, dividing the land between into square lots for houses, according to the grid plan that Laclede provided to him. Chouteau and his crew measured off three large blocks for the village center. The one on the first terrace above the Mississippi became *Place d'Armes*, an open, grassy field where a militia could drill and train[42] and,

Auguste Chouteau, co-founder of St. Louis. Steel engraving, circa 1898. *Courtesy of the Missouri History Museum, St. Louis. N11891: Portraits Collection.*

alternately, an open marketplace where villagers would exchange the various crops they grew in the Common Fields. Finally, *La Place* would be a space where outdoor festivals were held. Many years later, the first roofed market house in St. Louis was erected there. It was replaced in time with a sizable brick marketplace.

The block west of *La Place* became the company block, Laclede's Block, where a fur trading post was constructed of stone. For the first four years, it also served as the family home. After he became a successful merchant, Auguste expanded it into the first great Creole mansion in the mid–Mississippi River Valley.

The third block west of the Mississippi was designated the Church Block. A vertical-post Catholic church would later be constructed there, along with a house for the priest. The north side of the block became the village cemetery. All that remains to be seen today of Laclede's original plan above ground is something of the Church Block, although it's very different in appearance.

However, hidden inside the second bluff, slated to reopen in 2017, is a newly expanded museum beneath the Gateway Arch, where a fascinating interactive model developed by historian Dr. Bob Moore Jr. of the National Park Service will allow visitors to virtually explore colonial St. Louis from underground.

Shortly after the birth of her fourth and last child in March 1764, Marie Bourgeois Chouteau left New Orleans by boat for Fort de Chartres with five-year-old Jean Pierre, three-year-old Marie Pelagie, thirteen-month-old Marie Louise and newborn Victoire. Laclede welcomed them after what must have been an exhausting three-month river journey and rode guard beside the cart that carried them to the village of Cahokia, Illinois, where he had made temporary living arrangements for his family until their house across the river was finished.[43]

In Cahokia, founded in 1696, they would have attended Mass at *L'Eglise de Sainte Famille* (the Church of the Holy Family), the first Catholic church west of the Allegheny Mountains. Although the original building (on

which the first and second churches in St. Louis were modeled) burned and had to be replaced by a similar one, a reconstruction of the house now known as the Old Cahokia Courthouse across the Mississippi River from St. Louis, constructed in about 1740, was standing when the Laclede-Chouteau family lived there.

A majority of the houses at Post St. Louis would be designed in a similar French colonial style, with vertical log posts set either *poteaux-sur-sol* (posts on sill) like buildings in Cahokia and Ste. Genevieve or *poteaux-en-terre* (posts-in-earth) on the limestone bluffs of St. Louis. Charles Peterson, the godfather of historic preservation in the United States, traced the origin of this architectural style to Normandy, France.[44]

Unlike Old Cahokia Courthouse as it now appears, many St. Louis homes were stuccoed and whitewashed inside and out so that the vertical beams holding up the walls didn't show. But they shared the same steeply hipped roofs that protected the *galleries* (porches) and stuccoed walls from rain and snow.[45]

In September 1764, when the fur trading post (which was not *poteaux-en-terre* but almost entirely stone) was completed, Laclede crossed the river with Marie and their younger children. According to family legend, he lifted her in his arms and carried her across the threshold of their first real home.

Marie Chouteau thus became the first Creole woman to take up residence west of the Mississippi River. Pragmatic, good-natured, resilient, shrewd when it came to business and generous with her neighbors in sharing medicinal remedies from the garden she cultivated, Marie Chouteau would become known as *la mere de Saint Louis* (the mother of St. Louis). She and Laclede quite literally seeded colonial St. Louis. Before her death in 1814 at age eighty-one, Marie Chouteau had seen the arrival of fifty grandchildren.[46] She survived the Battle of St. Louis and witnessed the transfer of St. Louis and the Louisiana Territory from France to Spain, from Spain back to France and finally from France to the United States of America.

By Christmas 1764, St. Louis was an outpost of approximately forty settlers perched on the edge of the frontier. West winds buffeting the bluffs could be fierce, and temperatures swung from below-zero degrees Fahrenheit in the winter to close to one hundred degrees in summer. But according to French documents translated by nineteenth-century historian Frederic Billon, over the next several months, so many residents of the Illinois side of the Mississippi moved to St. Louis, along with families from Ste. Genevieve and New Orleans and former French militiamen from Fort de Chartres (now fully transferred to Britain), that "the village seemed to spring into existence in 1765."[47]

Although town lots on which to build houses and planting strips in the Common Fields were initially and verbally assigned by Pierre Laclede, and though the settlement was widely referred to in the early years as Laclede's village, the name under which he established it was St. Louis, for Louis IX, the patron saint of his king, Louis XV of France.

Laclede's formation of the community was inspired by French law (he was the son and younger brother of attorneys) and infused with the independent spirit of his native Bernais and perhaps by his reading of French philosophers. But he, and the entire village, would be guided by Captain Louis St. Ange de Bellerive, the former commandant of Fort Vincennes and Fort de Chartres.

Many years Laclede's senior, St. Ange was a wise and respected leader with decades of experience in tribal relations. After formally turning Fort de Chartres over to the British, he made St. Louis his home. Until Spanish lieutenant governor Pedro Piernas formally took control of St. Louis in 1770, a council of six St. Louisans governed the village, having unanimously voted St. Ange as "acting-governor." Spanish and French law were closely related, and because of what Laclede had set in motion, there was a peaceful if not completely joyful transfer of power.[48]

Colonial St. Louis was not a perfect place. Slavery existed from the founding of the trading post, both African American and Native American slavery. But almost from the founding, free blacks like Jeanette and Gregoire Forchet were allowed to join the village and given town lots on which to build and Common Fields rows to plant alongside their mostly French, Canadian and Creole neighbors. Nevertheless, as late as 1865 and beyond, black St. Louisans would suffer restrictions that their white counterparts would not.

Some French Canadian trappers and traders, including Jean Marie Cardinal, lived with their Native American wives and children in St. Louis. Before the colonial period ended, individuals of many different tribes would also reside in St. Louis along with Italian, Irish, Dutch and Swiss settlers.

Before recent archaeological excavation nearby proved otherwise, it was believed that the only colonial artifacts remaining downtown were preserved in the crypt of the Basilica of St. Louis, King (the Old Cathedral), on the riverfront. They are, notably, "Pierre Joseph Felicite," the first bell in St. Louis, christened on December 24, 1774,[49] and the early church registers of baptisms, marriages and burials.

The museum in the crypt has been redesigned and expanded as part of the major restoration of the church and rectory undertaken for the celebration of the 250th Anniversary of the Founding of St. Louis

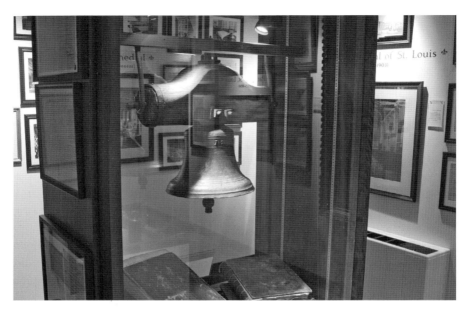

"Pierre Joseph Felicite," first bell in St. Louis. *Courtesy of the Basilica of St. Louis, King of France (the Old Cathedral) Museum. Thomas P. Kavanaugh, ed.*

Commemorative plaque at the burial site of Ottawa chief Pontiac, southeast corner of Broadway and Walnut Street. *Thomas P. Kavanaugh, ed.*

throughout 2014. Archbishop Joseph Rosati, who built the first Catholic cathedral west of the Mississippi, is there interred.

One of the most famous visitors to Colonial St. Louis is, according to local tradition, only the second person still buried on the river bluffs downtown. Very well hidden, several feet below the southeast corner of Broadway and Walnut Street, are the remains of Ottawa chief Pontiac. Between 1762 and 1764, Pontiac organized widespread attacks against British forts ranging from Lake Superior to the lower Mississippi, many with devastating success. His own siege of Fort Detroit ended in a truce, after which he made his way to St. Louis. But village life proved too dull, and he crossed the Mississippi River to Cahokia, where, on April 20, 1769, Pontiac was killed by a Peoria brave whose family member he had attacked years before.[50]

According to the recollection of Pierre Chouteau (who would have been about ten years old at the time), Pontiac's body was brought back to St. Louis, and he was buried with honors on the hill above the village,[51] in the French military coat he often wore. A memorial plaque on the west wall of a parking garage at the corner of Broadway and Walnut Street commemorates what is believed to be his burial site.

Until very recently, Chief Pontiac's remains were considered to be the last uncovered vestiges of St. Louis's shrouded colonial past. But in 2011, repair work necessary to the high-volume Poplar Street Bridge began to afford archaeologists with the Missouri Department of Engineers an opportunity to examine the ground below the bridge for archaeological remains prior to construction work.[52] To date, they've uncovered post molds for three separate French colonial vertical-post houses erected between 1769 and 1780, as well as numerous artifacts including a lead seal, gun flint and pieces of Rouen-tradition faience produced between 1740 and 1790,[53] in addition to so many other artifacts from that period through the Civil War era to the early twentieth century that it's taken more than a year to catalogue them.

In surprising ways, St. Louis's rich colonial past refuses to remain hidden.

# Chapter 5

# The Battle of St. Louis
# (*L'Année du Grand Coup*)

In a broad sense, it can be said that the American Revolution began and ended within a single block in downtown St. Louis. Pontiac's Rebellion and the onslaught of Indian attacks that it inspired on British forts from the Great Lakes to the Gulf of Mexico eventually led to Parliament levying taxes against its American colonies to pay for additional arms and reinforcements, which led to the Boston Tea Party and the American Revolution. Pontiac's burial site is commemorated at Broadway (which is Fifth) and Walnut Streets.

One block east down the hill, the Tower of Fort San Carlos stood in what is today the intersection of Fourth and Walnut Streets. From that modest, three-and-a-half-story structure, Spanish militia and St. Louisans, greatly outnumbered, fended off a British-led attack by mostly warriors from the area of the Great Lakes in May 1780, bringing the final battle of the Revolutionary War on the western front to a close.

Colonial St. Louis changed little under Spanish dominion except in the critical area of defense. French remained the most common language spoken, imports continued flowing in from France and French customs and traditions prevailed, although legal documents began to be recorded—and government correspondence conducted—in Spanish.[54] Throughout the entire Louisiana Territory, it became illegal to enslave Native Americans by a Spanish law instituted in 1769 (which was greatly ignored).

Pierre Laclede established St. Louis, but Fernando de Leyba, the Spanish captain assigned to St. Louis as lieutenant governor of Upper Louisiana in 1778, would save it from falling to the British in 1780.[55] Unlike Kaskaskia,

Fort de Chartres and Cahokia, St. Louis was never even briefly a part of the British empire in North America.

No image of De Leyba is known to exist. He died a little over two years after arriving in St. Louis with his family in June 1778. He lost his wife to illness in September 1779, and following his own death on June 28, 1780, he was buried beside her inside the Church of St. Louis IX.[56] Their orphaned daughters, Josefa and Rita de Leyba, were entrusted to the Ursuline Sisters in New Orleans.[57] St. Louis could not have been a happy place for the De Leyba family.

Fernando de Leyba governed St. Louis more strictly than his predecessor, Francisco Cruzat, who'd been popular with St. Louisans, but his strategic planning and experience as a seasoned battle officer prevented the village's devastation. American colonists on the eastern seaboard had been at war with Great Britain since 1776, with almost no effect on St. Louis. But in January 1778, Governor Patrick Henry of Virginia instructed Lieutenant Colonel George Rogers Clark to lay siege to British strongholds in the Illinois Country, right across the river. After taking Fort Kaskaskia on July 4, 1778, Clark moved on to capture Cahokia and then Fort Vincennes in what would become Indiana.[58] Spain declared war on Britain in 1779, and Clark urged De Leyba to fortify St. Louis against an attack that he believed would be coming from Detroit. Indeed, after Spain entered the war, orders went from London to British command in Canada to capture St. Louis and retake their former British holdings on the east side of the Mississippi from the Americans.

Fernando de Leyba was at an extreme disadvantage in following Clark's advice. When he sought financial aid and military support from Spain, he was left entirely to his own resources. Having already personally provided gifts to visiting tribes, he then had to pour more of his financial reserves into the village's defense.

Word reached St. Louis in late March 1780 that several hundred Indians from the Great Lakes area were preparing an attack engineered by the British. De Leyba ordered reinforcement of the village's existing stockade fence and drew up plans for four stone towers to be constructed equidistant along it. He lived long enough to see only one of those towers realized (minus its roof) and one other begun. No fortifications were needed on the east side of the village, for St. Louis had been wisely situated atop the sheer, forty-foot bluffs that fronted the Mississippi and provided a natural wall of defense.

On May 2, 1780, an army consisting of several hundred Sante Sioux, Chippewa, Winnebago and Menominee warriors, with smaller groups from

several additional tribes, recruited by British sergeant J.F. Phillips, under the command of Captain Emanuel Hesse and led by Sioux chief Wabasha and Chippewa chief Matchekewis, began to make its way south from Prairie du Chien, Wisconsin. It included several French traders and *coureurs de bois* (Canadian traders, woodsmen) sympathetic to the British. As the attacking force moved south, it swelled with close to 250 Fox and Sac warriors, bringing the total number close to 1,000.[59]

With neither time nor money to complete the other three towers he'd planned, De Leyba ordered two trenches dug around the perimeter of the village fence—one from the north and one from the south—beginning at the river and approaching the tower, which was positioned just above and behind, almost the center of the village proper. Constructed of native limestone, the tower of Fort San Carlos stood approximately thirty feet in diameter and thirty-five feet tall, providing a sweeping view in all directions.[60]

He also sent militia to the abandoned Fort San Carlos near the confluence of the Mississippi and Missouri Rivers to retrieve whatever firepower remained, and they returned with five cannons, minor artillery and ammunition. Shortly after his arrival in St. Louis, De Leyba had created a small cavalry division to support the infantry. The tower, the trench, the use of cavalry and preparation of the villagers for responsibilities when an attack occurred provided the potential that St. Louis would survive.

When news arrived on May 9 that the enemy numbered over 1,000, De Leyba ordered Spanish militia up from Ste. Genevieve and called for assistance from settlers within a sixty-mile radius of the village, raising the defensive force to about 350. Friendly Indians reported on May 23 that the enemy force was within sixty miles of St. Louis.[61] Five cannons were mounted atop the tower, which had been christened Fort San Carlos to honor King Charles III of Spain.

May 25 was the Feast of Corpus Christi, and St. Louisans celebrated in traditional French style with an outdoor festival following Mass. Never in the fourteen years since Laclede and Chouteau had established the fur trading post had it been attacked by Native Americans within two hundred miles. Many villagers were skeptical of the lengths in labor and cost to which De Leyba had been going.

May 26 dawned a beautiful spring day, and several farmers, field hands and slaves left the village stockade to work in the prairie Common Fields that spread west and north over an area of nearly twenty blocks.[62]

The British commander of the invading force, Captain Hesse, split his force into two groups for simultaneous attacks on Cahokia and St. Louis.[63]

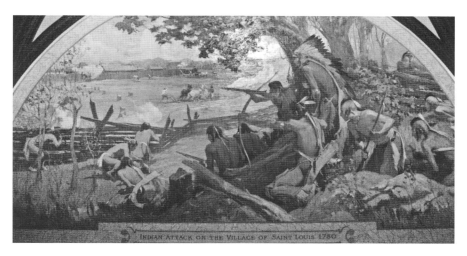

*Indian Attack on the Village of St. Louis Under British Command, 1780,* by Oscar E. Berninghaus. *From the Missouri State Capital Building, Jefferson City, Missouri.*

The latter descended on the people in the fields—some from the west and others from behind the Big Mound in the north—capturing twenty-five, wounding seven and killing twenty-one people.[64]

Jean Marie Cardinal, for whom Cardinal Avenue in St. Louis is named, was one of the first to die, but his Pawnee wife, Marianne, and their seven daughters and son survived. Another fortunate villager was an unnamed slave who turned on the warrior chasing him, wrested his gun away and killed him, making his way to safety.

As the alarm spread, Spanish militia and St. Louisans took their planned positions, with militia manning the cannons on top of the tower as well as the trenches. The attack was ferocious and bloody. Most of the women and children rushed to safety inside the stone government house, but several women joined in the fighting. It's been written that among these was Marie Josepha Rigauche, the wife of a trader and the village girls' schoolteacher, who risked her life several times, leaving the village gates armed with a pistol and knife to help those fleeing from the Common Fields to safety.[65]

Cannon fire proved a turning point in the battle. Although gravely ill, Fernando de Leyba issued commands from the top of the Tower of Fort San Carlos. British officers and their Indian allies were stunned when the cannons began to fire, for they had believed the village to be virtually undefended. Many of the Indians fled, as would their British commanders, leaving behind the dream of capturing the Mississippi River Valley from St.

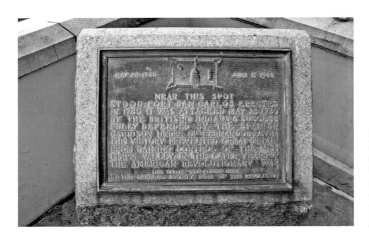

Fort San Carlos Memorial, erected by the General Society of the Sons of the Revolution. *Thomas P. Kavanaugh, ed.*

Louis. On their way out, warriors burned houses, laid waste to crops in the outlying fields and captured another forty-six people along the Mississippi River. But the vast majority of St. Louis held.[66]

From the southwest corner of Fourth and Walnut Streets in downtown St. Louis today, you can just make out the diagonal lines of the Mississippi River's new suspension bridge at St. Louis, the area from which part of the British-led Indian assault began at one o'clock on the afternoon of May 26, 1780. But on that day, it would have been all but impossible to make out their encroachment, even from the top of the Tower of Fort San Carlos, for warriors wisely hid their approach behind the largest of the Mississippian burial mounds on the west side of the river.

Following the death of Lieutenant Governor Fernando de Leyba on June 28, 1780, Francisco Cruzat was reassigned to that post in St. Louis, the Upper Capital of the Louisiana Territory. He would complete the fort De Leyba had designed and begun, only to have Spain relinquish St. Louis to France in 1800.[67]

During the city's bicentennial anniversary in 1964, Mayor Alfonso Cervantes requested acquisition of the Spanish Pavilion following the close of the World's Fair in New York to establish a landmark in downtown St. Louis commemorating Spain's importance in our colonial history.[68] Today, a small monument celebrating Fort San Carlos, commissioned by the General Society of the Sons of the Revolution, stands just outside the Broadway entrance to the Spanish Pavilion, which was expanded into a hotel (today the Hilton Hotel at the Ballpark).[69]

## Chapter 6

# GATEWAY TO THE WEST

O f the many nicknames that St. Louis gained over time—the Mound City, *Pain Court* (Short of Bread), River City, the Brick City, Great Metropolis of the Mississippi Valley and Capital of Ragtime—the Gateway to the West is the best known, due in large part to a soaring steel arch that, upon completion in 1965, won international renown as a masterpiece of modern art and architecture.

From the Illinois side of the Mississippi, the Gateway Arch seems built to frame the city's skyline, but St. Louis municipal law has preserved the far greater symbolism of the tallest man-made monument in the United States—that is, President Thomas Jefferson's purchase of the Louisiana Territory from France in 1804 and the eventual expansion of the nation to the Pacific coast.

By the restriction of construction of every building in downtown St. Louis to less than the Arch's 630-foot height, the view beneath its apex remains unobstructed, drawing the eye westward and suggesting a horizon far beyond the city.

With the 1814 publication of a *Map of Lewis & Clark's Trek, Across the Western Portion of North America from the Mississippi River to the Pacific Ocean*, copied by Samuel Lewis from William Clark's original drawing, the possibility of forging a better life in the West became the dream of thousands of easterners and immigrants to the United States who would make their way to St. Louis, where the first trail west began, stock up on provisions and head west on the Oregon Trail.

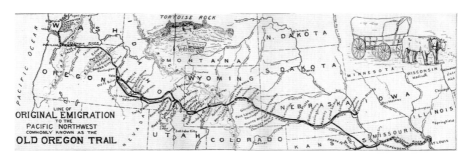

*Map of the Oregon Trail. Courtesy of the University of Texas Libraries, University of Texas–Austin.*

St. Louis began emerging as the Gateway to the West with its founding of what historian Frederick Fausz defined as an Indian center of commerce in the mid–Mississippi River Valley.[70] Like the ancient Mississippian capital at Cahokia, St. Louis was located at the vortex of an enormously rich area of natural resources.

Although it lacked the Illinois side of the river's deep, rich soil, St. Louis had an advantage that Cahokia didn't. It was situated not on a floodplain but safely above and beside the greatest river system of natural highways in North America, the Mississippi, and its access to the Missouri, Illinois, Ohio, Arkansas and Red Rivers.

Laclede's village welcomed Native Americans to trade here, and they came in the hundreds. It attracted large numbers of merchants who wanted to do business with tribal nations and even greater numbers of trappers and engagés, in the beginning almost exclusively French Canadian *voyageurs* and traders, who dealt directly with Indian tribes in their own villages and returned with Indian goods to St. Louis.

By the time Meriwether Lewis and William Clark returned from the expedition commissioned by President Jefferson with a mapped route to the Pacific Ocean in 1806, St. Louis was firmly established and ideally situated as the last commercial outpost for fur trappers and traders, adventurers and trailblazers, gold miners, homesteaders and settlers because of its location.

For decades, a handsome slab of rough-cut and polished rose granite, indigenous to the state of Missouri, has marked the site of the First Trail West (the beginning of the Santa Fe and Oregon Trails in downtown St. Louis) on the east side of Kiener Plaza across from the Old Courthouse. An initiative of the St. Louis Chapter of the Daughters of the American Revolution and the State of Missouri, the First Trail West Marker is presently in storage

while the Kiener Plaza section of the Gateway Mall is undergoing renovation as a park space set to reopen in the spring of 2017.

The Corps of Discovery launched its expedition from Camp Du Bois, Illinois—the winter camp built under Clark's supervision near the confluence of the Mississippi and Missouri Rivers where the men were rigorously trained[71]—with farewell celebrations in the little settlement of St. Charles, Missouri. But in important ways, the Lewis and Clark expedition began and ended in St. Louis.

Meriwether Lewis and William Clark spent part of the winter of 1803–4 in St. Louis leading up to the official transfer of St. Louis acquiring provisions, hiring skilled river men[72] and gaining important information from the Chouteaus about tribes they would encounter at the beginning of their journey.

Rose granite "First Trail West Marker" in the Gateway Mall, dedicated by the Daughters of the American Revolution and the State of Missouri. *Photo by Maureen Kavanaugh.*

The official transfer of Upper Louisiana from France to the United States began on March 9, 1804, as a Spanish flag flew over the village, continued while (for sentimental reasons) a French flag was allowed to fly for several hours, and ended on March 10 when the Stars and Stripes of the United States were raised over St. Louis. During this time the explorers were guests in the home of Pierre Chouteau, who along with his brother Auguste and their brother-in-law, Charles Gratiot, were among the village's leading merchants in the fur trade. St. Louis had flourished with Indian commerce since its founding, and the Chouteaus had grown prosperous.

Auguste managed the family business from St. Louis with whatever trips were required to and from New Orleans, while Pierre spent most of his time living and working in Indian country to the north and the west. Their maps and their understanding of tribal ways, along with which tribal nations might be friendly, proved invaluable to the Lewis and Clark Expedition.

A short distance south of Pierre's home on *Rue Royale* (Main Street), Auguste had expanded the original fur trading post into a striking limestone residence in the French colonial style of New Orleans, with black walnut floors polished to a sheen that reflected like a mirror. Trappers and traders met at Chouteau's mansion in large numbers, as did members of numerous tribal nations, to conduct business.

The Chouteaus and the Gratiots were gracious hosts with large extended families and considerable personal libraries. They shared their knowledge of areas through which Lewis and Clark would be traveling and included them in festive gatherings. Upon their return in 1806, Meriwether Lewis and William Clark stayed in the home of Pierre Chouteau, who stored the specimens they'd collected until they transported them to Washington.[73]

This was likely the American explorers' introduction to a distinctly French Creole culture. Whether Meriwether Lewis was attracted enough to St. Louis ever to make it his permanent home will remain forever a mystery, for he died within three years of completing the enormous challenge Jefferson set for him, in the midst of his tenure as governor of the Louisiana Territory.

St. Louis historian Thomas Danisi revealed in *Uncovering the Truth About Meriwether Lewis* that when Lewis mortally shot himself on October 11, 1809, along the Natchez Trace en route to Washington, D.C., he was in the throes of blinding headaches and other debilitating symptoms of advanced malaria.[74] Danisi did this by uncovering Lewis's medical records between 1795, when he apparently contracted malaria as a young soldier stationed at Fort Greenville, Ohio, and 1809, when Dr. Antoine Saugrain of St. Louis had been treating him over a period of several years for his ever-worsening condition.[75]

Malaria is a pernicious, mosquito-born disease. During this era, some were fortunate to die relatively quickly of malaria, while other victims succumbed with an agonizing slowness. It is believed that malaria also took the life of Pierre Laclede, who had been ill for months and died on his way back to St. Louis from New Orleans in 1778.

Antoine Saugrain was one of the most fascinating and quietly influential individuals in St. Louis history. A native of France, Saugrain was trained as a physician and chemist in Paris before immigrating to the United States. He arrived in St. Louis between 1799 and 1800 and purchased a stone house near the southern end of the village constructed early in the colonial period.[76]

Saugrain began a garden with plants and trees that he brought to St. Louis, using the medicinal plants and herbs that he cultivated in his practice of medicine. He was not only treating Meriwether Lewis for malaria, as his

detailed medical ledger (discovered by Thomas Danisi in the Pettis County Historical Society and Museum in Sedalia, Missouri) indicated; Saugrain also provided medical supplies for the Corps of Discovery.[77] In 1809, Dr. Antoine Saugrain became the first physician west of the Mississippi River to prevent smallpox with the Jenner cowpox vaccine, treating everyone who came to him without regard to race, class or their ability to pay him.

Over time, Saugrain's garden became one of the wonders of St. Louis. It is said to have inspired a young British immigrant named Henry Shaw, who arrived in St. Louis in 1819[78] and later established the Missouri Botanical Garden on his country estate and endowed the School of Botany at Washington University, St. Louis.

It's also unknown what William Clark made of St. Louis upon his arrival, but after the successful completion of his assignment from President Jefferson, after visits to Washington for commendation and home to Kentucky, where he married Julia Hancock, Clark accepted a presidential appointment as superintendent of Indian affairs of Upper Louisiana and brigadier general

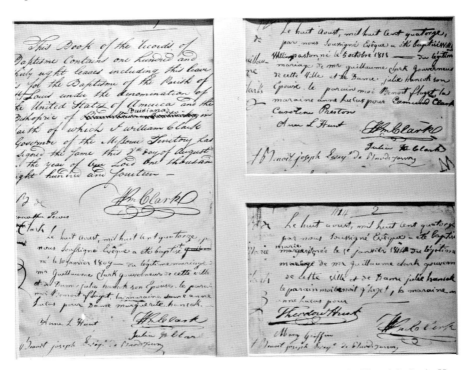

Document signed by William Clark in St. Louis, 1814. *Courtesy of the Basilica of St. Louis, King (the Old Cathedral) Museum.*

of the Territory Militia, making St. Louis his home for the rest of his life. In the thirty-plus years that William Clark lived in St. Louis, it evolved into a very American town.

Sometime during his tenure as governor of the Missouri Territory (an appointment by President James Madison), William Clark built a fine brick Federal-style home just north of the north leg of the Gateway Arch. According to historian Bob Moore Jr. of the National Park Service, the dimensions of that house matched almost exactly the dimensions of the Nicholas Jarrot House, which survives in Cahokia village across the Mississippi River from St. Louis.[79]

Tribal delegates came from as far west as the Rocky Mountains to negotiate with Clark for protection of their ancestral lands, bringing him gifts of beautifully handmade tribal artwork that he hung from the walls of his council house until it became something of a museum. William Clark's council house, which stood beside his home, inspired the Museum of Westward Expansion, housed for almost half a century, between 1965 and 2015, in a vast space hewn out of the bluff on which the Gateway Arch stands.

Clark became the father of eight children and one of St. Louis's leading citizens. Anglican by faith, he was a charter member of Christ Church in St. Louis. Unable to have had a formal education himself, Clark sent his sons and Sacagawea's son, Jean-Baptiste Charbonneau, to St. Louis College, the beginning of St. Louis University, the first university west of the Mississippi River.

According to the early records of the Basilica of St. Louis, King of France (the Old Cathedral), Jean Baptiste Charbonneau, youngest member of the Corps of Discovery and son of French Canadian trader Toussaint Charbonneau and his Shoshoni wife, Sacagawea, was baptized on December 28, 1809, by a visiting Trappist monk, Father Urbain Guillet, in the second vertical-post church in St. Louis.[80] Among those present were his father and his mother, the remarkable young Shoshoni woman who proved so critical to the success of the Lewis and Clark Expedition. Auguste Chouteau was his godfather, and Chouteau's twelve-year-old daughter, Marie Therese Eulalie Chouteau, his godmother.[81] This information was made known by historian Bob Moore Jr. in the February 2000 edition of *We Proceeded On*, the official publication of the Lewis and Clark Trail Heritage Foundation.

Sacagawea, who was already ill when she left St. Louis with Charbonneau on April 2, 1811, in the company of a fur trading party and would be dead within two years, left Baptiste (who gained the nickname "Pompey" during

the expedition) in the care of William Clark, whom she had come to trust. Shortly after giving birth to her daughter, Lisette, Sacagawea died on December 20, 1812, at Fort Manuel in the Dakota Territory. Lisette was also placed in the care of William Clark but did not survive childhood.

Jean Baptiste Charbonneau lived a full and fascinating life. After leaving school, he traveled in both Europe and Africa. Returning to the United States, he worked as an interpreter, explorer, trapper, guide, military scout and miner, even serving briefly as *acalde* for Mission San Luis Rey, California.[82] He spoke several languages and was known to quote Shakespeare on the trail. He died of pneumonia on May 16, 1866, and is buried in Danner, Oregon.

On September 23, 1806, to the astonishment of the villagers of St. Louis who had feared them lost, Captains Meriwether Lewis and William Clark, along with most of the Corps of Discovery, straggled their way into port. As their boat was sighted, everyone hurried to greet them.

After they were wined and dined and rested in the house of Pierre Chouteau, what unimaginable stories they had to tell St. Louisans, who had welcomed them into their homes in the winter of 1803–4—stories of mountain ranges far higher than any yet recorded in the nation, of

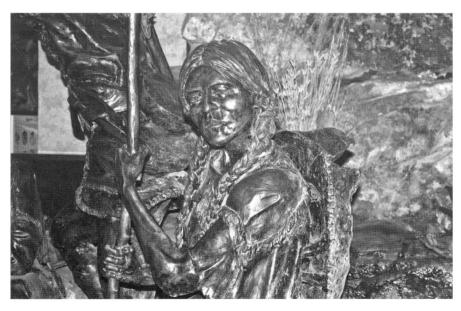

*Sacagawea with Jean-Baptiste Charbonneau*, by Harry Weber. In the lobby of the Drury Plaza Hotel. *Courtesy of Drury Development Corporation. Thomas P. Kavanaugh, ed.*

incalculable natural reserves that lay west of the Mississippi and Missouri Rivers, of a continental divide, of massive buffalo herds and prairie dogs, of rainforest and ocean sound and of a young Shoshoni interpreter of incredible courage who had made the entire journey with an infant on her back.

Published accounts by members of the Corps of Discovery brought great numbers of pioneers to and through St. Louis, transforming it into a commercial gateway and the frontier capital of the west. William Clark, who was responsible for much of this, died in the home of his son, Meriwether Lewis Clark, whom he'd named for his best friend, on September 1, 1838, at the age of sixty-eight. A commemorative plaque on St. Louis Place, at the southeast corner of Broadway and Olive Street in downtown St. Louis, marks his death place. William Clark is buried at Bellefontaine Cemetery in north St. Louis.

Chapter 7

# FRONTIER CAPITAL

There are two houses in downtown St. Louis where time stands still. The first is the birthplace of the journalist and poet Eugene Field (constructed between 1829 and 1845). The second became the family home to an Irish mountain man named Robert Campbell. Both houses are, in effect, time capsules of an era when St. Louis reigned as the cultured and sometimes boisterous capital of the frontier west.

There is a locked bookcase on the second floor of the Field House that someone unseen opens without the key. From the third-story library of the Campbell House, after the curators have left for the day, setting the security system before they go, someone turns the fainting couch around, opens the shutters and watches neighbors walk their dogs or fly by on skateboards as the city lights come up.

Purchased in 1854 by Robert Campbell of County Tyrone, Ireland, the Campbell House today consists of a charming three-story brick townhouse, carriage house and garden with the oldest gazebo/Victorian summerhouse in downtown St. Louis. It's tucked away at Fifteenth and Locust Streets amid the taller, twentieth-century commercial buildings and warehouses that replaced its elegant nineteenth-century neighbors.

A museum since 1942, Campbell House is a treasure-trove of documents and artifacts, including invoices and receipts from the fur trade, moccasins, trade beads, Robert's handsome buckskin coat and leggings handmade on the Great Plains and a beautifully fringed coat, custom made for a child, from St. Louis's growth years as the frontier capital of the west.[83]

"Boy's Elk Hide Coat of Western Cut."
*Courtesy of the Campbell House Museum, St. Louis.*

Of course, the frontier kept pushing westward until it reached the Pacific Ocean, and its capital would change over time. When Robert Campbell immigrated to St. Louis in the early 1820s, the area where his home now stands was still prairie (more about Campbell and his house in subsequent pages).

Following the War of 1812, southerners like William Ashley also made their way to St. Louis and began to capitalize on the possibilities opened up by the Corps of Discovery's findings. Born in Virginia in about 1778, Ashley came to Missouri as a young man, mined saltpeter for gunpowder in the southern part of the state and turned to trading in Ste. Genevieve.

Ashley left the War of 1812 a brigadier general of the Missouri militia and headed to St. Louis, where he built a house on top of a Mississippian mound above the town. It was standing when Titian Peale and Thomas Say surveyed the St. Louis Mound Group in 1819, for they made note of it on the southwest corner of the square, Mound 11. By 1820, according to historian Frederick Hodes, Ashley also had a two-and-a-half-story brick residence in the southern part of the town.[84]

Although St. Louis was never its official capital, it can be said that St. Louis gave birth to the state of Missouri on September 18, 1820, when the first session of the General Assembly was held in the Missouri Hotel at Main (now North First) and Morgan Streets,[85] where Raeder Place stands on Laclede's Landing today.

In the final chapter of the first volume of his evolving, encyclopedic history of St. Louis, *Beyond the Frontier*, Hodes does a marvelous thing. He takes the reader on an autumn walking tour of St. Louis in 1820. Except for early subdivisions slowly developing where the third bluff rolled west into prairie and where the original Common Fields lay, St. Louis still hugged the river. Hodes aptly titles it "The Walking City."[86]

Beginning at the southern end of Main Street, Hodes heads north, pointing out buildings, residents and businesses along the way. They include merchants, auctioneers, newspapers, churches, inns and taverns, physicians, counselors at law, cabinetmakers, livery stables, apothecaries, midwives, clock and watch makers, silversmiths and jewelers, stonecutters, carpenters, bricklayers, soap and candle factories, wheelwrights, blacksmiths, saddle and harness manufacturers, tailors, boot makers, musicians, confectioners and bakers.[87]

There were as yet no gated places separating wealthy residents from the working class and poor. Regardless of race or economic status, everybody knew who just about everybody else was,[88] and surviving on the edge of the frontier was still a collective effort. There was an air of sophistication about St. Louis combined with a palpable aura of adventure that attracted many headed west to settle here instead.

In 1822, General William Ashley established the Rocky Mountain Fur Company with Major Andrew Henry, advertising "for enterprising young men to ascend the Missouri River to its source."[89] Initially known as "Ashley's One Hundred," the company came to include Jim Bridger, Jedediah Smith, Jim Beckwourth, Thomas Fitzpatrick and William Sublette, all of whom became legendary mountain men.

"Enterprising Young Men" newspaper advertisement. *Courtesy of the Missouri History Museum, St. Louis. NO7685: Missouri Republican, March 27, 1822.*

Jedediah Smith rediscovered the South Pass, a much more accessible route to Oregon for covered wagons than the one mapped by Lewis and Clark. Mauled badly by a bear in 1823, he kept exploring new territories until semi-retiring from the mountains and buying a townhouse and farm in St. Louis in 1830, only to be killed by Comanches the following year at the age of thirty-two.[90]

Born into slavery in Virginia in about 1800, Jim Beckwourth was the son of a white father and a black mother. Later freed by his father and apprenticed to a blacksmith in St. Louis, he became a trail guide, army scout and member of the Crow Nation.[91]

Thomas Fitzpatrick was born in Northern Ireland in 1799 and left home at seventeen to become a sailor. He was twenty-three when he became one of Ashley's hundred. In his early fifties, Fitzpatrick married a young Arapaho woman.[92]

At age seventeen, Jim Bridger was the youngest man to sign on to the expedition. Like Ashley, he was a native Virginian. Tall, lean, kind and powerful, he carried a Bible that he read by the campfire. He was the first white man to see and describe the Great Salt Lake. In 1850, he would discover a shortcut through the Rocky Mountains that would become known as Bridger's Pass, later used as the route for the Union Pacific Railroad.[93]

Life in the American West was arduous and fraught with danger. Exposure to harsh weather, attacks by wild animals and unfriendly tribal warriors cut short the lives of many adventurers. But some found it invigorating and beautiful. Robert Campbell was one of them. He signed on to William Ashley's 1825 fur trading expedition under Jedediah Smith and became a mountain man,[94] trapping and trading and writing letters home to Ireland about the tribal chiefs he'd met and seas of tipis on the Great Plains. Over the long, lonely months of an expedition, fast and enduring friendships were formed, as personal stories were shared and co-workers came to one another's rescue.

Smith, Bridger, Beckwourth and Fitzpatrick—Campbell got to know them all. But it was a plucky trailblazer from Kentucky named William Sublette,[95] the first guide to lead a wagon train to the Rocky Mountains, with whom Robert Campbell would set up a business. When they returned to St. Louis permanently after close to a decade in the Rocky Mountains, Sublette and Campbell opened a trading company at 7 North Main Street, supplying friends who remained in the fur trade and pioneers headed west.[96]

A steady stream of steamboats now plied the Mississippi, and furs were being shipped not only south to New Orleans and out through the Gulf of Mexico but also increasingly north to the Great Lakes and over the Atlantic

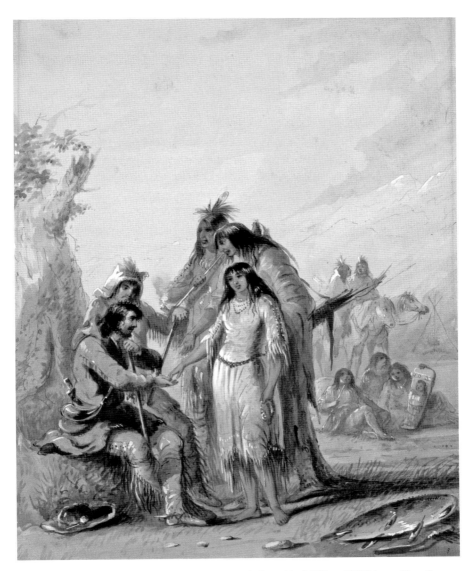

*The Trapper's Bride*, by Alfred Jacob Miller, commissioned by William T. Walters. *From the Walters Art Museum, Baltimore, Maryland.*

to European markets.[97] Lead mined in southern Missouri and processed in St. Louis was now competing with fur as a major export, but fur would reign supreme here for three-quarters of a century. According to Charles Brennan and Ben Cannon in *Walking Historic Downtown St. Louis*, "In 1821, the trade represented an estimated $600,000 of the town's $2,000,000 in commerce."[98]

Exhibit in the Old Courthouse of "Manuel Lisa's Fur Warehouse." *Courtesy of Bob Moore Jr., the Jefferson National Expansion Memorial. Thomas P. Kavanaugh, ed.*

And while young and hardy mountain men made their way in and out of town on business, tribal delegates of many Indian nations continued visiting to conduct business of their own. St. Louis was incorporated as a city in 1822, but it still had very much a small-town feel, which it retains to this day.

William Sublette gave up shop keeping to develop a health spa and wildlife preserve on one thousand acres of land he'd purchased six miles southwest of the city that came complete with a segment of the River Des Peres and sulfur springs. There he built cabins for guests and kept horses, sheep, cattle, swans and buffalo, creating St. Louis's first health resort. He also mined coal there and laid out a track for horse racing.[99]

During the early 1820s, St. Louis became home to Henry Shaw, who was importing stainless steel cutlery from his native Sheffield, England, and selling it to pioneers and St. Louisans alike, and to gunsmiths Jacob and Samuel Hawken, who were fine-tuning one of the most famous rifles in the West. They called it the Rocky Mountain Rifle, but it came to be known simply as the Hawken rifle. It was lightweight and accurate, with a long range. Every Hawken rifle was made by hand, and it was available only in St. Louis, where the Murphy wagons built for the huge freight loads carried on the Santa Fe Trail were also constructed.

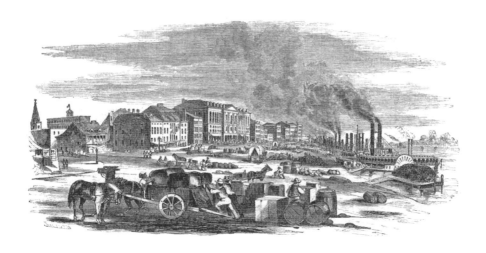

*The Levee at St. Louis*, 1857, illustration from *Ballou's Pictorial Drawing Room Companion*, Boston, Massachusetts.

Trained by their father, the Hawken brothers refurbished guns and produced axes, swords and tomahawks, but they became famous for the high-quality plains rifles that they handcrafted in their St. Louis shop.[100] William Ashley is said to have purchased the first one. But Kit Carson, Jedediah Smith and, later, Theodore Roosevelt also owned Hawken rifles.

According to historian William Barnaby Faherty in *The St. Louis Portrait*, by the 1840s St. Louis University had opened a medical college and a law school on its Washington Avenue campus, Shakespeare's works were being performed in the St. Louis Theater designed by Meriwether Lewis Clark, city residents owned some sixty-seven steamboats and "prominent Europeans came to St. Louis to outfit for hunting parties with Plains Indians."[101] Adventurous artists like Karl Wimar, John Casper Wild, George Catlin and Karl Bodmer arrived to secure the guides and provisions they needed to record Native American culture in the Mississippi Valley and far west[102] before it all but disappeared from the earth.

William Sublette died suddenly on July 25, 1845, in Cincinnati, Ohio, while en route to Washington with his longtime partner and friend, Robert Campbell. It was left to Campbell, shocked and grief-stricken, to purchase a casket and ship William's remains to St. Louis by steamboat, accompanied by his widow, Frances Sublette.[103] He is buried at Bellefontaine Cemetery in north St. Louis, not far from his good friend.

Chapter 8

# BRICK CITY

M ay 17, 1849, was a blustery night in St. Louis. Not an unusual thing, for spring is an especially active season for high winds and tornadoes in the city of St. Louis and throughout the Midwest. But it proved to be a perfect storm for the city's volunteer fire brigades, a storm tragically without any rain.

The alarm went off at 9:00 p.m. when a mattress caught fire aboard the paddle-wheel steamer *White Cloud*. Crewmembers thought they'd doused it but unknowingly left it smoldering. By 10:00 p.m., when the men of the Missouri No. 5 volunteer fire brigade arrived at the foot of Cherry Street, where the *White Cloud* was moored, the boat was ablaze.[104]

They cut it loose from its moorings, hoping the steamer would clear the levee and move into the channel, but a brisk northeasterly wind drove it southward into some thirty other boats docked along the five blocks between Cherry Street (today Franklin Avenue) and Locust Street. Twenty-three steamboats, including the *White Cloud*, were lost.[105] How many people may have been lost aboard the boats is unknown.

Sparks from the fire ignited freight sitting on the levee including tobacco, hemp, cotton and other cargo, spreading to the shanties where poor dockworkers and their families lived near Front Street. With the boats fronting the levee ablaze, the largest source of water, the Mississippi River, was unavailable to firefighters, and water from the city reservoir soon ran out.

As the fire leaped to buildings along streets running south and west of the wharf, it became clear to Thomas Targee, captain of the Missouri Brigade,

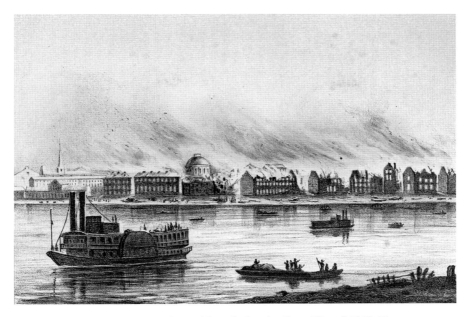

Illustration of the St. Louis riverfront ablaze during the Great Fire of 1849. From a German book published in 1856.

that a firebreak was needed along Second Street, whereby buildings could be exploded to halt the fire's spread.[106] He sent to the arsenal, three miles south of downtown, for gunpowder; perhaps with a sense of foreboding, he made a quick trip home, where he lived with his family, eleven blocks west of the riverfront, and kissed them all goodbye. They never saw him again.[107] Thomas Targee was the father of ten children.

The Catholic Cathedral, barely five years old, stood just beyond Second Street (originally *Rue de L'Eglise*/Church Street) in the inferno's path. Targee—a native New Yorker, auctioneer by trade and director of the choir at Christ Church—courageously volunteered to carry a keg of gunpowder into the Phillips Music Store on Market Street. But he no sooner stepped inside than it exploded, blowing him to pieces.

Thomas Targee was one of three known casualties of the Great Fire of 1849 and the first U.S. firefighter to die in the line of duty.[108] The fire raged for more than eight hours before the city's many volunteer brigades got it under control. All told, some thirty-four river craft (including steamers, barges and smaller boats) and 430 buildings (which included the city's post office, three banks and three major printing shops, one of which managed to get the story out before being abandoned to the flames)—almost the

Raeder Place/Christian Peper Tobacco Company Buildings. *Thomas P. Kavanaugh, ed.*

entire central business district and most of what remained architecturally of colonial St. Louis—were lost.

The more stringent building code adopted in the wake of the worst fire in St. Louis history mandated that buildings be constructed of brick or stone, and over time, St. Louis gained perhaps its least well-known nickname, the Brick City.

Laclede's choice of this site for a fur trading post contained not only defensive limestone bluffs and prairies for farming and grazing but also natural springs, some coal and numerous rich clay deposits that proved beneficial to succeeding generations. Brickyards sprang up south and west of downtown, nineteen and possibly part of a twentieth in the Cheltenham area alone, all of which Bob Corbett, longtime professor of philosophy at Webster University, listed in his "Dogtown: List of Mines Updated November 4, 2004."[109]

William Carr Lane—a native of Pennsylvania, physician and the first mayor of St. Louis—constructed the town's first brick house in 1813 at 73 South Main (First) Street. According to Jacob Thompson of ATEK Tuck Pointing and Brick Repair, in 1821 one-third of the houses in St. Louis were constructed of brick. By 1875, 90 percent of the city was brick built. He asserted that to this day, brick remains the first choice of homebuilders in the St. Louis area.[110]

But the city's brick imprint ranged far beyond St. Louis. As early as 1855, the Cheltenham Fireclay Works, with administration offices on Market Street downtown, was exporting bricks as far north as Canada and as far to the east as Africa. For decades, mound-shaped kilns used to fire clay bricks lined Manchester Avenue alongside the railroad tracks for rapid export out of St. Louis.

*United States Geological Survey Bulletin 438*, written by N.M. Finneman in 1911, noted, "The output of clay products from St. Louis was, in the year 1908, valued at $5,000,000. This is about one-thirtieth of the entire output of the United States….Inasmuch as…these were derived in large part from a single area within the city limits, it may be seen that this area is one of the most important centers of the clay industry." The clay was mined like coal by way of shafts or slopes from a depth of generally less than one hundred feet.[111]

A leisurely drive from the north end of St. Louis to the south reveals a wide variety of brick colors, ranging from light beige to dark brown, from a pale rose to bright red. It's believed that the richest clay in the metropolitan area was used in the construction of the Wainwright Building, designed by Louis Sullivan and engineered by Dankmar Adler. The master ceramists of Winkle Terra Cotta in Cheltenham, six miles west of downtown, produced the magnificent designs that Louis Sullivan sent from Chicago.

As reported in the *New York Times* in September 2010, the economic recession that occurred in the United States in the late twentieth and early twenty-first centuries has resulted in a phenomenon called "brick rustling" in mostly decaying areas of older American cities like St. Louis, Detroit and Cleveland.[112] While some of the fires that reap a bounty of cleaned, usable bricks are accidental, there's evidence that many are purposely set so that thieves can harvest them and sell them on the black market to developers in other cities. In 2011, the owner of one brickyard estimated that several tractor-trailer loads of stolen bricks leave St. Louis every week for states in the south like Louisiana, Florida and Texas.

Chapter 9

# A HOUSE DIVIDED

B egun in 1826 and completed in 1862,[113] a grand courthouse stands in a place of prominence in downtown St. Louis. For nearly one hundred years, it was the place where St. Louisans and many from far beyond St. Louis sought justice. After the new and larger Civil Courts Building was constructed six blocks west in 1930, it became a museum, and it remains so today. It is also a place of celebration where festivals are held and naturalization ceremonies take place for new citizens of the United States.

The Old Courthouse is, in a way, downtown St. Louis's attic, containing an odd assortment of pieces of the city's and the wider area's past that are, from time to time, shuffled, put on display or hidden away. These include a time capsule sealed in the golden ball atop the courthouse's splendid dome, a prairie schooner, remains of an early fur warehouse that evolved into a famous jazz club, upstairs courtrooms where reenactments of the landmark Dred Scott Case take place and images of St. Louis's colonial village.

Operated by the National Park Service, St. Louis's Old Courthouse is the westernmost part of the Jefferson National Expansion Memorial at St. Louis, and it offers the best long view of the Gateway Arch on this side of the Mississippi from the top of its east staircase.

While there is no more architecturally daring structure in downtown St. Louis than Eero Saarinen's radiantly reflective steel arch, there is perhaps no more historic building than the Old Courthouse, which the Arch frames. For it was here in 1846, when the United States was barely seventy years

The Old Courthouse, framed by the Gateway Arch from Kiener Plaza, 2014. *Photo by Maureen Kavanaugh.*

old, that an American named Dred Scott, who'd been born into slavery in Virginia between 1795 and 1800, sued for his freedom.

As the underlying question of what constitutes natural American citizenship and the wider moral question of what defines personhood, humanity with respect to race, were passionately argued, Scott's initiative set into motion here one of the most important legal cases in U.S. history and sowed the seeds for civil war. The implications of the case after it was tried twice and a St. Louis jury found in favor of Dred Scott and his family—his wife, Harriet Robinson Scott, and their daughters, Lizzie and Eliza—would rock the nation after it moved from the Supreme Court of Missouri to the Supreme Court of the United States, which handed down a disastrous decision on March 5, 1857.

St. Louis had been from colonial times a place where it was possible for slaves to purchase their freedom. But Dred Scott had tried unsuccessfully

to do so, as had many others whose owners made the cost of freedom impossibly high. It was then, with the help of Henry Taylor Blow, the son of his first owner, that Scott sought legal recourse at the courthouse in St. Louis.

In the early years of the nineteenth century, Auguste Chouteau and Judge Jean-Baptiste Lucas had each donated a portion of their adjoining Common Fields property for the site of a courthouse at the center and top of the third natural bluff that fronts the Mississippi River at St. Louis. The new courthouse would overlook the original village proper, which was standing between it and the residential developments springing up in the prairie Common Fields to the west.

They couldn't have picked a more perfect spot. When completed in 1862 (twenty-three years after St. Louis architect Henry Singleton began his work on it), the courthouse—crowned with William Rumbold's elegant, copper-faced, cast- and wrought-iron dome, the first of its kind in the United States[114]—could be seen for miles. All manner of legal issues would be decided in the courthouse on the hill and many vital issues debated in the rotunda, which could hold thousands.

Dred Scott sued for his freedom on the grounds that he had been forced to work as a slave in the free state of Illinois and the free Wisconsin territory for close to seven years. But the question was raised as to whether slaves of African origin were citizens of the United States and had the right to sue.

Scott's attorney, Vermont native Roswell Field, who lived with his family five blocks south of the courthouse on Fifth Street (today Broadway), argued that Dred Scott was an American citizen because he had been born in the state of Virginia.[115] Attorney Hugh Garland, himself a native Virginian, argued for the defense that since Scott was "of pure African blood" and descended from ancestors brought to this country as slaves, he was not an American citizen and had no right to sue.[116]

Unlike many slaves who had successfully sued for their freedom in the St. Louis Courthouse, Dred Scott and his family remained in bondage, his owner, Irene Sandford, having launched a legal battle that would last several years.

By 1850, the Scotts' case was still making its way through the courts, and the population of St. Louis had reached 77,860[117] (within a decade it would more than double). St. Louis was now the second-largest port in the United States after New York Harbor and the commercial center of the fur trade. The racially integrated, almost classless, closely knit community that had begun as French colonial St. Louis had disappeared, replaced by a sprawling and very divided American city.

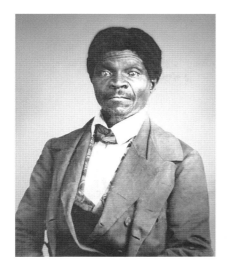 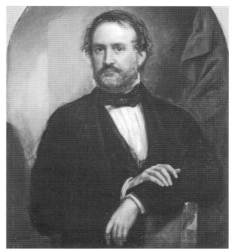

*Left*: Dred Scott (circa 1799–1858), the most famous American to sue for his freedom in the courthouse in St. Louis.

*Right*: Portrait of Roswell M. Field, the St. Louis attorney who represented Dred Scott. *Courtesy of the Field House Museum, St. Louis.*

Famine in Ireland and revolt in Europe brought a flood of immigrants to St. Louis beginning in the 1840s. They enriched St. Louis's already diverse mix of cultures with their dreams and their skilled labor, but many also brought with them prejudices and conflicts from their homelands. In 1849, immigrants also brought cholera up the Mississippi River by steamboat from New Orleans,[118] the worst epidemic in the city's history, leaving more than four thousand people dead, one-third of them children.

By 1860, St. Louis had proportionately the largest immigrant population of any city in the country.[119] There was growing tension between immigrants and native Missourians, a large percentage of whom were of southern descent. In the decade leading up to and during the Civil War, St. Louis was as divided as any city in the nation—politically, ethnically, racially and economically—and the courthouse that began as a relatively small building required expansion in three directions.

Ironically, this very divided city would prove critical to saving the Union. The Federal Arsenal of the West, located three miles south of the courthouse, was prevented from falling into secessionist hands in May 1861 by an enormous show of Union force organized by Federal officer Nathaniel Lyon, an easterner recently posted to St. Louis, who ordered several

thousand troops to surround the Confederate-leaning Missouri Militia at Camp Jackson and seize its arms.[120]

Within shouting distance of the courthouse in all directions lived in the late 1850s an array of citizens whose disparate views on secession from or preservation of the Union reached a climax on May 10, 1861, at Camp Jackson at the present intersection of Grand and Lindell. Known to be Southern sympathizers, the Missouri Militia set up Camp Jackson supposedly for training exercises, but Federal officer Nathaniel Lyon discovered that the actual purpose was to take over the arsenal three miles south of the courthouse. Lyon ordered Federal troops to surround the camp.[121]

The ensuing street battle on May 10, 1861, left close to one hundred injured and twenty-eight dead, including a twelve-year-old boy and a fourteen-year-old girl. The "Affair at Camp Jackson" became nationally sensationalized in newspapers as the "Massacre at Lindell's Grove," engendering tremendous support for the Confederacy in St. Louis and throughout much of rural Missouri.[122]

The following day, a column of Missouri Home Guards—Union loyalists—were fired upon in retaliation by civilians as the Guards marched up Walnut Street, one block south of the courthouse. Eight civilians and four soldiers were killed outright. One of the wounded died several days later.[123]

Finally, on June 17, civilians attacked five companies of the Missouri Home Guard as they approached the intersection of Seventh and Olive, two blocks north and west of the courthouse. Several soldiers returned fire. On this occasion, the fatalities included one police officer and three citizens who were upstairs in the Recorder's Office when bullets came through. Another victim died later of his wounds. As a result of these skirmishes, martial law was declared in St. Louis and lasted until 1865.[124]

Ulysses Grant later wrote in the 1870s that had the Federal Arsenal at St. Louis, where an enormous amount of ammunition was manufactured, fallen to secessionists in the spring of 1861, the Union army could not have won the war.

The Confederacy blockaded the Mississippi south of Memphis, bringing river traffic to a standstill and halting the transfer of critical supplies to Union forces in the South. St. Louis businessman James Buchanan Eads, a brilliant, self-taught engineer, designed and built a flotilla of iron-clad gunboats that successfully broke the Confederate blockade. Packed with ammunition and medical supplies from St. Louis, Eads's ironclads enabled the Union victory at Vicksburg, Mississippi.[125]

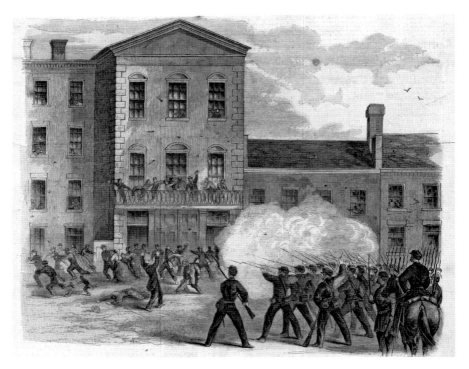

*The Fire of Troops*, from *Frank Leslie's Illustrated Newspaper*, June 29, 1861. *Courtesy of the Missouri History Museum, St. Louis. Photographs and Prints Collection. P0084-1317: Civil War Collection.*

By the late 1850s, slavery was not popular in St. Louis, but it remained the largest center for slave trade in Missouri. But there also existed in the city support systems for slaves trying to attain their freedom, which included white St. Louisans opposed to slavery and free blacks and former slaves who had become successful and influential businesspeople.

One of the most prominent was Reverend John Berry Meachum, who had been born into slavery in Virginia in 1789. Trained from boyhood as a carpenter, Meachum became so skilled a craftsman that in his early twenties he was able to buy his freedom and that of his father. When his wife, Mary, was taken to St. Louis by her owner, Meachum followed and purchased her freedom as well. John Berry Meachum became one of St. Louis's leading businessmen. With minister John Mason Peck, he founded the First African Baptist Church in Missouri.[126]

As Meachum's carpentry business expanded to include the construction of riverboats, he bought slaves and employed them, making it possible

for them to earn their own freedom. He then established the "Candle Tallow School" beside his church.[127] After a St. Louis law passed in 1847 re-enforcing the Missouri Literacy Law of 1819 that forbade assembling and teaching black slaves to read or write forced its closure, Meachum moored a steamboat in the Federal waters of the Mississippi River and established the "Floating Freedom School," complete with desks and a library.[128] Among its graduates was James Milton Turner, first African American delegate to a foreign nation. Appointed by President Ulysses S. Grant, Turner, who had co-founded the Lincoln Institute in Missouri in 1866 for African American students and teachers, served as U.S. ambassador to Liberia from 1871 to 1878.[129]

Dred Scott's support system came, ironically, from the same family who once owned him. When the decision of the St. Louis jury was overturned by the Missouri Supreme Court, members of the Blow family encouraged Dred and helped pay for his appeal to the Supreme Court of the United States. Tragically, that court upheld the state court decision and further stated that slaves of African origin were not full human beings and had no rights of citizenship.

Dred Scott died of tuberculosis in St. Louis a little over a year after being freed by his friend, Taylor Blow, who had grown up beside him and who manumitted all four members of the Scott family in May 1857.[130]

A sculpture of Dred and Harriet Scott stands adjacent to the staircase on the east side of the Old Courthouse along the block of Fourth Street between Market and Chestnut Streets, renamed in his honor Dred Scott Way. Harriet and Dred Scott have living descendants in St. Louis today.

The Blow family, who became politically and philosophically divided over the issues of slavery and states' rights, was not exceptional in mid-nineteenth-century St. Louis. Many families, neighborhoods and religious congregations split right down the middle. St. Louisan Edward Bates, attorney general of the United States under President Abraham Lincoln during the Civil War, had a son who fought for the Union and a son who fought for the Confederacy.

Political divisions also arose between immigrant groups. Many St. Louis Germans, having experienced the violent repercussions of anarchy in their homeland, saw the need for a strong central government and supported the Union.[131] The Irish, on the other hand, had been suffering under political and religious oppression since the time of Elizabeth I of England. Opposed to a strong central government, many St. Louis Irish supported the Confederacy.[132]

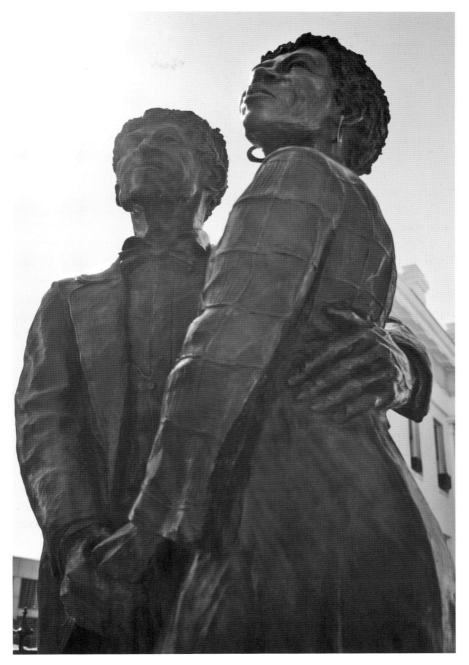

Detail of Harriet and Dred Scott sculpture by Harry Weber, adjacent to the east side of the Old Courthouse. *Thomas P. Kavanaugh, ed.*

Elizabeth Hobbs Keckley, who became Mary Todd Lincoln's seamstress and modiste in the White House, lived during the late 1850s in the block directly across Broadway from the courthouse. Born a slave in Virginia in 1818, Keckley was brought to St. Louis by her owners. Within a short time, she became famous for her beautiful sewing and fashion design. With the help of some of her elite St. Louis customers, Elizabeth Keckley was able to buy her freedom and that of her only child, George, before making her way east to Washington, D.C.

One block north of the courthouse at Broadway and Pine Street (where the Metropolitan Square skyscraper stands today), the secessionist paramilitary group that called itself the "Minute Men" held court and did its planning in the two-story brick Greek Revival mansion of the Berthold family, while pro-Union militia drilled and trained in the Mercantile Library Building in the next block.[133]

Meriwether Lewis Clark, William Clark's oldest son, lived in a home directly across Fifth Street from the Berthold mansion. Born in St. Louis in 1809, he had attended St. Louis College as a boy before graduating from the U.S. Military Academy at West Point in 1830. Trained as an engineer and architect of the St. Louis Theater and St. Vincent de Paul Church, Clark would serve as a colonel in the Army of the Confederate States of America.[134]

A block west and north of Broadway, notorious slave dealer Bernard Lynch operated one of two slave pens. The other was a two-and-a-half-story brick house that stood two blocks south of the courthouse at Broadway and Myrtle (today Clark) Street. Lynch fled St. Louis in 1861, and the Union army took possession of it, turning the building into the Myrtle Street Prison.

In 2014, during reconstruction work on the Poplar Street Bridge, archaeologists with the Missouri Department of Transportation (MODOT) came upon the remains of a few buildings below the bridge dating to French colonial St. Louis, along with the foundation of a building that had belonged to Eliza Haycraft, one of St. Louis's most famous madams.[135]

Cast out of her family's home in Callaway County, Missouri, because of a scandal at the age of twenty, Eliza made her way to St. Louis, where like many other destitute and illiterate women she resorted to work as a prostitute.[136] Eliza Haycraft was intelligent as well as beautiful. Investing in commercial and residential real estate while managing her bordellos, she became a highly successful businesswoman. The frequent subject of a scandal sheet tabloid called *The Joker's Budget & Mysteries of St. Louis*

during her lifetime, Haycraft would be eulogized as a philanthropist for her generosity to the poor. Having known poverty herself, she reportedly never turned anyone away who came to her for help.[137]

According to columnist Bill McClellan of the *St. Louis Post-Dispatch*, when Eliza Haycraft died at age fifty-one in her fine home on St. Charles Street, five blocks from the courthouse, her estate was valued at $250,000 (today roughly the equivalent of $30 million), the bulk of which went to charity.[138]

One block south of Haycraft's Poplar Street brothel, Dred Scott's attorney, Roswell Field, lived with his family in the corner building of Walsh's Row at Broadway and Cerre Street. The Eugene Field House is today a museum named for Roswell Field's son, Eugene, who became a noted newspaper columnist and poet.

And finally, there lived in an upscale townhouse on Chestnut Street, between Sixth and Seventh Streets (a block and a half west of the Courthouse), Margaret Parkinson McClure, who returned from the country estate she called Pine Lawn, many miles northwest of the city, on March 20, 1863, only to be placed under house arrest for carrying mail for Confederate prisoners and engaging in the passage of contraband.[139]

Her Chestnut Street house would be cleared of its furnishings and filled with cots, evolving into the Chestnut Street Prison for women. On May 13, 1863, St. Louisans watched in amazement as McClure and twenty other family members of Confederate soldiers were transported to the wharf at the foot of Pine Street, escorted aboard the steamer *Belle Memphis* and banished to the South for the duration of the war.[140] By that time, St. Louis hospitals were treating the wounded from both sides, and the largest Union prison in Missouri (located on Gratiot Street just south of downtown) was overcrowded with Confederate prisoners of war.

Even as the politics of war divided St. Louisans, the tragedies of war would draw the disparate parties of the city together. When the first wounded soldiers, Confederate and Union, began arriving in August 1861 after the Battle of Wilson's Creek in southern Missouri, they were met at the train station by members of the Ladies Union Aid Society, who provided them with bandages and clothing.[141]

Christmas Eve 1861 saw the sober arrival of some 1,200 Confederate prisoners, who were marched under armed guard from the Pacific Railroad Depot to what had been Dr. Joseph Nash McDowell's Medical College at Eighth and Gratiot Streets (and thereafter served as the Gratiot Street Prison). They were followed on February 20, 1862, by the first of the 12,000 Confederates soldiers whom General Grant had captured at Fort

Donelson, Tennessee, being routed through St. Louis to prison camps in Alton, Chicago and elsewhere.[142]

Before the week was out, the steamer *War Eagle* had arrived with another 150 wounded Confederate and Union soldiers, who were transported to hospitals on Fourth and Fifth Streets, the latter a five-story building across the street from the courthouse converted by the Western Sanitary Commission to serve as "City General Hospital" for the wounded.[143]

In February 1864, members of the Ladies Union Aid Society, the Western Sanitary Commission and other interested citizens gathered in the Mercantile Library to plan an enormous fundraiser to help thousands of wounded soldiers, refugees and freedmen who'd been forcibly displaced by the war. It would be held in a three-block area along Twelfth Street (today Tucker Boulevard).[144]

Titled the Grand Mississippi Valley Sanitary Fair, it was a month-long event that included places to eat and drink, entertainment venues, booths with prizes and, most popular of all, raffles where one could win such prizes as a five-hundred-acre farm, a rosewood piano, a pedigreed stallion and bars of Nevada silver valued at $4,000 each.[145]

The fair drew thousands of St. Louisans and was an enormous success, clearing approximately $555,000 (equivalent today to about $8.5 million); $345,000 (more than $5 million) was allocated for medical supplies, with the remainder divided among funds for soldiers and their families, refugees of the war and former slaves now free men and women.[146]

William C. Winter, who authored the definitive *The Civil War in St. Louis: A Guided Tour* for the Civil War Round Table of St. Louis, called the Grand Mississippi Valley Sanitary Fair "the greatest civic event of the war years."[147] Although divisions remained, healing began as St. Louisans came together in a concerted effort to aid those who had lost so much in the war, at home and elsewhere. According to Frederick Fausz in *Historic St. Louis*, an estimated $4.5 million was raised by St. Louisans for distribution to "soldiers and needy civilians throughout the nation."[148]

# Chapter 10
# GREAT RIVER METROPOLIS

B y 1870, Laclede's vision that the site he had chosen for the fur trading post of Maxent, Laclede & Company would someday perhaps become *"une des plus belles villes de l'Amerique"* (one of the finest cities in America)[149] had been realized. St. Louis was a great river metropolis of elegantly designed buildings and gardens, grand hotels, universities, hospitals, libraries and a population exceeding 300,000 people. Gone were the prairie schooners and horse races in the street of its frontier days. Elegant "floating palaces" sailed in and out of the port like the steamboat pictured on the Common Seal of the City of St. Louis above the entrances to city hall.

Sam Clemens, now known to the world as Mark Twain, had given up piloting steamboats for the craft of writing, although he would recollect them in "Old Times on the Mississippi," a series of articles that he penned for the *Atlantic Monthly* in 1875. The articles were later expanded into the book *Life on the Mississippi*; he noted that no work he'd ever done had given him more pleasure.

Clemens came to St. Louis from Hannibal in 1853 at the age of eighteen and later quipped, "The first time I saw St. Louis I could have bought it for six million dollars, and it was the mistake of my life that I didn't do it."[150]

Captain Horace Bixby, who taught Clemens the Mississippi between St. Louis and New Orleans, lived in Lafayette Square, just south of downtown in a house that's still standing. He would outlive the cub pilot he'd trained by just a few years. When Bixby learned that Clemens was close to death, he reminisced about their first meeting. He was in the pilothouse of the

Mark Twain by Mathew Brady, February 7, 1871 (detail). *Courtesy of the Library of Congress, Prints and Photographs Division, Brady-Handy Photograph Collection.*

paddle-wheeler *Paul Jones*, docked at Cincinnati, when a lanky young man entered the doorway and asked in a drawl that he never lost, "Say, will you teach me the river?"[151] And teach him, Bixby, one of the greatest steamboat captains of the era, did—all the ins and outs, the twists and turns, the shallows and deep fathoms of it. You can read an electronic edition of Mark Twain's "Old Times on the Mississippi"[152] online courtesy of the University of North Carolina at Chapel Hill (http://docsouth.unc.edu/southlit/twainold/twain.html). Delight in the spirit of adventure and camaraderie and the rich, evocative wordplay that went back and forth between the seasoned captain and the cub pilot who would make him famous as they navigated one of the world's greatest and most treacherous rivers. You will feel like you're right on deck alongside them. It's delicious reading.

Some say that the excitement of the golden age of the steamboat culminated in a great race that began in New Orleans on June 30 and ended in St. Louis on July 4, 1870, between the *Robert E. Lee* and the *Natchez*, over a distance of 1,154 miles (1,857 kilometers), to determine which was the fastest boat on the Mississippi.[153] The *Robert E. Lee* won the challenge in three days, eighteen hours and fourteen minutes. The *Natchez* came in second, arriving in three days, twenty-one hours and fifty-eight minutes, having been delayed by heavy fog and passenger stops. But there were times along the way when the steamers were almost even. At Baton Rouge, Louisiana, the *Robert E. Lee* had only a six-minute advantage. Bonfires lit up the night for crowds cheering as the boats passed Memphis.[154]

Betting on the race rose into the millions, as the captains of the two boats, John W. Cannon of *Robert E. Lee* and Thomas P. Leathers of *Natchez*, were accomplished sailors and notoriously bitter rivals. Reporters dispatched from Boston, New York, Philadelphia, London and Paris to cover the race

relayed updates by telegraph even as crowds in the thousands watched the race from the shorelines along the way.[155]

An estimated crowd of ten thousand in St. Louis eagerly waited to see which steamboat would round the bend and make it into port first. *Robert E. Lee*'s arrival was met with cheering and fireworks. Cannons boomed, church bells rang and boat and train whistles sounded. The captain and crew of the *Natchez* also received a warm welcome. There were great celebrations in St. Louis that night.

The city of St. Louis wraps itself around the great bend that the Mississippi makes here, having fallen in love with the river in infancy, when Laclede poised it safely atop its bluffs. Not quite one hundred years later, by 1873, the Port of St. Louis was brimming with people and commerce.

James Buchanan Eads was completing a magnificent, triple-arched bridge that spanned the Mississippi. Taking his inspiration from a fourteenth-century arched stone bridge in Koblenz, Germany, and ignoring the rebukes of prominent engineering rivals that he'd never accomplish the design, Eads set world records when it opened in 1874.[156]

The first bridge to connect Illinois and Missouri at St. Louis, Eads Bridge was the first major usage of steel (2,390 tons of it), the first primarily steel bridge in the world (its granite-faced, limestone piers sunk to bedrock) and, at 6,442 feet (1,964 meters), the longest bridge ever constructed up to that point.[157]

Eads had arrived in St. Louis in 1833 at the age of thirteen with his family aboard the *Carrolton*, which caught fire as it was pulling into the wharf. He and his family escaped, but eight other people were killed. Everything the Eadses owned except for the clothes they were wearing was lost.[158]

James sold apples on the levee to help support his family and then got a job as a messenger for merchant Barrett Williams, who allowed him the free use of his extensive private library. There, Eads taught himself engineering.[159] His first major accomplishment was the design of a river salvaging boat by which he accrued his first small fortune. The average life of a steamboat on the Mississippi River in the nineteenth century was short. They caught fire, blew up or sank. Whatever wasn't claimed from the river bottom within seven years became eminent domain. Eads's second major accomplishment would be the design and construction of the ironclad gunboats that facilitated the Union army victory under Grant at Vicksburg, Mississippi. The third would be the St. Louis bridge.

It may be that no one ever loved the Mississippi River more than Sam Clemens and James Buchanan Eads, although they knew it differently.

Eads Bridge, St. Louis, 1874. Chromolithograph by F. Welcker, published by Compton & Company. *Courtesy of the Library of Congress, Prints and Photographs, Division Washington, D.C., 20540 USA.*

Mesmerized by it from boyhood, one would grow up to bridge it at St. Louis and later deepen its mouth, thereby saving the Port of New Orleans.[160] The other would set a great American novel on it and make it world famous as "the Father of Waters."

By the spring of 1873, it could be said that Robert Campbell had finally arrived—this young man who'd arrived in St. Louis from Northern Ireland with dreams of adventure and making his fortune in America in the early 1820s, when the population was approximately ten thousand people, and watched it emerge into a metropolis thirty times that size. He'd become a clerk, mountain man, trapper, trader, merchant, banker and advocate for tribal nations to the United States government. He'd also given a young man named Sam Clemens his first job as a fully licensed steamboat pilot.[161]

After decades of hard work and a few near disasters in business, Robert Campbell and his wife, Virginia Jane Kyle Campbell, were comfortably established with their three surviving sons in the three-story Victorian town house they had purchased in 1854 at 20 Lucas Place (today 1508 Locust Street). Robert was so preoccupied with business that Virginia had free rein

*Left*: Robert Campbell, mountain man and businessman. *Courtesy of the Campbell House Museum, St. Louis.*

*Right*: Detail of portrait of Virginia Kyle Campbell. *Courtesy of the Campbell House Museum, St. Louis.*

in imprinting their home with her own personal style, which is preserved in the Campbell House Museum today.

One afternoon in the spring of 1873, the Irish and German immigrants who staffed the house were busy with Virginia making final preparations for what would be an unforgettable evening at Campbell House: the president of the United States, Ulysses S. Grant, and his family would soon be arriving for dinner.[162] General William Tecumseh Sherman, General William Harney, James Buchanan Eads and their families were among the many St. Louis guests who would also be there to welcome them.

Virginia would have drawn the evening's menu and the recipes prepared from a cookbook she was compiling of favorites over the years, some of which she'd brought from Raleigh, North Carolina, as a young bride in 1841 and which the museum has recently published with fascinating details about St. Louis in the Gilded Age.

But despite the many comforts of wealth, the Campbell family experienced a great deal of personal tragedy. Between 1844 and 1864, Virginia and Robert lost ten children before the age of eight. Only three sons would

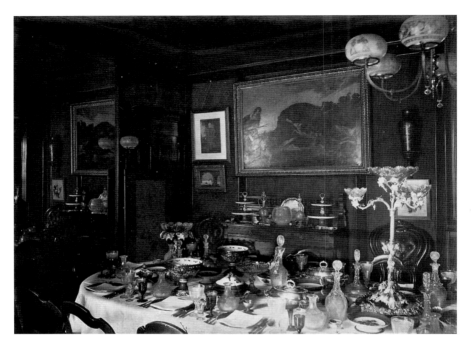

Photograph of the southwest corner of the dining room in the Campbell House Museum, taken by Hugh Campbell, circa 1880. *Courtesy of the Campbell House Museum.*

live to adulthood. Just two of their thirteen children were daughters. Lucy died at age two of measles and Mary at the age of one from encephalitis. The years 1847 and 1862 must have been particularly painful years for the Campbells, for in each of those years they buried two little children.[163] None of the Campbell sons married and there were no grandchildren to carry on the family name, yet their house lives on.

The Campbell House Museum contains the parlor and dining room furniture around which President Grant, James Eads and many other friends were entertained—including the legendary Belgian Jesuit Peter DeSmet, who taught English at St. Louis University on Washington Avenue before becoming a missionary to Native American tribes in the West. His photograph and one of the Grant family can be seen in the Morning Room.

In 1875, Richard J. Compton designed and edited *Pictorial St. Louis, Great Metropolis of the Mississippi Valley, 1875*, one of the most remarkable city books ever published in America. Containing 122 large folio pages and illustrated with tens of thousands of buildings—homes, churches, universities, theaters, lumberyards, flour mills, factories and other

businesses[164]—it failed as the advertising promotional piece it was intended to be but would prove a treasure-trove to future historians and genealogists. Thousands of structures were numbered, corresponding to a legend at the bottom of each page indicating what the building was or who owned it.

Campbell House, the first house built on exclusive Lucas Place, remains one of only four structures still standing today—along with Christ Church Cathedral on Thirteenth Street, Centenary Methodist Church on Sixteenth Street and St. John the Apostle and Evangelist Catholic Church on Chestnut Street—out of the hundreds depicted in Camille Dry's amazing bird's-eye view of this one area of St. Louis.[165]

*Pictorial St. Louis* is on permanent display, on a very large stand, in the St. Louis Room of the Central Building of the St. Louis Public Library in downtown St. Louis, where countless historians, St. Louisans, and visitors from all over the country have thumbed through it searching for where someone lived or where something stood in 1875, when St. Louis was the great metropolis of the Mississippi Valley.

# Chapter 11

# THE FOURTH CITY AND EPICENTER
# OF RAGTIME

The late nineteenth and early twentieth centuries marked an especially rich musical, literary and architectural era in what is now downtown St. Louis, fed by the great migration north of former slaves and their children, by immigrants from Europe and the British Isles who continued arriving in large numbers and by first-generation Americans coming into their own.

The period from 1880 to 1910 saw the St. Louis Symphony Orchestra emerge as the second-oldest symphony in the nation. Street balladeers chronicled sensational crimes in song, and ragtime musicians led by Scott Joplin and Thomas Million Turpin were taking the city and the nation by storm with new rhythms and syncopated melodies that echoed the music of the streets and the Industrial Revolution.

Kate (Katherine O'Flaherty) Chopin, who was born in St. Louis in 1850 and attended the Sacred Heart Academy at Fifth and Market Streets as a girl,[166] had returned from Louisiana following the death of her husband and was writing fiction inspired by Creole culture. As she struggled to support her six children, all of whom she had given birth to in nine years, Chopin gave voice to questions about marriage, passion and her identity as a woman. Her novel *The Awakening* would be groundbreaking, modern for its time.

William Marion Reedy, who was born in the Kerry Patch in 1862 and began at St. Louis University at the age of fourteen, had moved from reporting the news for the *Missouri Republican* and *Globe-Democrat*[167] to editing one and then another weekly literary magazine. Reedy's *Mirror* gained national prominence as he published early, sometimes first works by

American writers including Emily Dickinson, Stephen Crane, Amy Lowell, Edward Arlington Robinson, Ezra Pound, Vachel Lindsay and St. Louis native Sara Teasdale.[168]

And a quiet lad named Thomas Stearns Eliot, born in 1888, began self-publishing his own literary magazine before the age of eleven, abbreviating his first two names with the initials "T.S." on the title page.[169]

Two of the most classically beautiful buildings went up—the U.S. Custom House and Post Office (today the Old Post Office) in 1884 between Olive and Locust Streets and Union Station in 1894 between Eighteenth and Twentieth Streets—as well as a visionary concept for the modern skyscraper, the Wainwright Building at Seventh and Pine. They remain crown jewels of downtown St. Louis architecture.

With the exception of a few references to Scott Joplin at the wonderfully interactive National Blues Museum on Washington Avenue, you have to go a few blocks west of today's downtown to see memorabilia related to the "King of Ragtime" and his remarkable St. Louis contemporaries, Tom Turpin and Louis Chauvin.

As most of the buildings in the Mill Creek Valley were being demolished in the 1960s,[170] black St. Louisans led an initiative to preserve one of the houses in which Scott Joplin had lived in St. Louis with his wife, Belle, worked as a composer and taught music. The initiative resulted in the State of Missouri creating the Scott Joplin State Historic Site by restoring that apartment building at 2658 Delmar[171] and expanding it into a neighboring building to commemorate the Rosebud Bar and Café (the original building having stood in the 2200 block of Market Street).

Scott Joplin was drawn to the St. Louis music scene by Tom Turpin, who owned and managed the Rosebud. An excellent pianist in his own right, Turpin was the first black composer to publish a work in ragtime, "The Harlem Rag," in 1896.[172] The Rosebud became famous for showcasing the talents of black musicians and for its dizzying piano competitions.

Joplin's most famous St. Louis compositions were "The Entertainer" and the beautiful "Cascades"[173] (inspired by the fountains cascading down from Festival Fall into the Grand Basin at the 1904 World's Fair). But the best-selling ragtime piece of all time is Scott Joplin's "Maple Leaf Rag" (1899). He would be posthumously honored with a Pulitzer Prize for his opera, *Treemonisha*.

Sadly, not a trace remains of the Rosebud Bar and Café,[174] which became for a time the national epicenter of ragtime when Scott Joplin and Tom Turpin held court. Both had come to St. Louis from the South. Turpin

Scott Joplin State Historic Site. The Mill Creek Valley residence of pianist and composer Scott Joplin. *Thomas P. Kavanaugh, ed.*

arrived in St. Louis as a boy with his family from Savannah, Georgia, in the early 1880s, and Joplin came on his own at the age of seventeen in 1885.

Also lost to posterity was the Booker T. Washington Theater, according to historian John Wright Sr. the first theater in St. Louis built by and for African Americans. It was owned by another member of the Turpin family, Tom's brother, Charles, who was elected constable in St. Louis in 1910.[175]

The most famous native St. Louis performer of the jazz age, Josephine McDonald (later Baker), who headlined at the Folies Bergère in Paris, said that she had begun her career, dancing "for pennies or pins," outside the Booker T. Washington Theater as a girl, where stars like Ethel Waters and Bill "Bojangles" Robinson performed inside.

The rise of the Wainwright Building between 1890 and 1892 at the corner of Seventh and Chestnut Streets embodied architect Louis Sullivan's vision of the modern skyscraper as a lofty and soaring form and one that was practical as well as beautiful. It was also symbolic of St. Louis's rise to fifth-largest city in the nation in 1890 when the population reached 451,770. By 1900, the count had risen to 575,238, making St. Louis the fourth-largest city in the United States, a place it would hold through 1910.[176]

At a mere ten stories and surrounded by much taller skyscrapers, the Wainwright Building is easily overlooked. Nevertheless, this early Sullivan masterpiece is considered by many to be the most important architectural structure in St. Louis, second in fame only to the Gateway Arch internationally. With the advocacy of the Landmarks Association of St. Louis and the support of Governor Kit Bond, the Missouri legislature preserved it for state offices in downtown St. Louis, rescuing it from demolition for city parking in 1973.[177]

Designed by Louis Sullivan and engineered by Dankmar Adler of Chicago, the office building commissioned by brewer Ellis Wainwright was a dramatic departure in style and purpose from the many three-story Victorian townhouses that originally stood around it.

Louis Sullivan, the father of modern western architecture, is the architect who set in stone and steel and terra cotta the theorem that "form ever follows function," which he saw as a law of nature.[178] He believed that it was also important for a building to be beautiful to honor the work of the humans inside. His careful attention to detail in the ornamental friezes of the Wainwright Building, which separate the third to ninth stories and accentuate the attic story, exemplify this.

Sullivan also believed that if you were going to disrupt the natural landscape with something built, you needed to bring elements of the landscape into the design so that the building looked like it belonged. Frank Lloyd Wright, who apprenticed under Adler and Sullivan, would become the American master of that principle. Look closely and you will see that Sullivan achieved this in the Wainwright Building with the lyrical, leafy designs of the horizontal friezes; by specifying unglazed clay for the bricks and terra cotta, preserving the naturally rich color of the clay; and by framing the windows with wood indigenous to the St. Louis prairie. Sometimes great treasures are hidden in plain sight. You miss the mastery of Sullivan's designs on the Wainwright Building unless you stop and look closely at them or trace with your fingertips the sinuous curves of the elegant doorways.

Adler and Sullivan would receive commissions for two more buildings within a few blocks of the Wainwright: the St. Nicholas Hotel and the Union Trust/705 Olive (which survives and is being adapted as a boutique hotel). The roof of one of its twin towers once held the highest beer garden in St. Louis, a title now held by the 360 Roof Top Bar at the Hilton Hotel at the Ballpark.

When St. Louis Union Station opened on Market Street between Eighteenth and Twentieth Streets in 1894, it was the largest passenger terminal in the world. Designed by German-born architect Theodore Link,

The Wainwright Building, an early Louis Sullivan masterpiece and one of the earliest successful steel-frame skyscrapers in the world. *Thomas P. Kavanaugh, ed.*

it was the second major landmark in downtown to celebrate the French origins of the city's founder. (The Old Post Office, with its steep Mansard roof and dry moat, was the first, and city hall, completed in 1904, would be the third.) The station's enormous train shed, designed by George Pegram, was in 1894 and remains today the largest single-span train shed ever built.[179]

Theodore Link's head house was Richardsonian Romanesque in design,[180] inspired by the medieval walled city of Carcassonne in southwestern France

Frankie Baker, 1899. *From the Collection of the St. Louis Mercantile Library at the University of Missouri–St. Louis. Collection: Globe-Democrat, M-112.*

and completely functional as a modern railway station. Through the front entrance, under the Whispering Arch and up the double staircase is one of the most stunning rooms in the nation, a grand lobby with an enormous, barrel-vaulted ceiling, marvelously designed by Charles Millet of Chicago with one surprise after another—Celtic interlacing, Islamic arabesques, Norman coats of arms and more than one hundred arches.

In the early morning of October 15, 1899, an event took place four blocks east of Union Station on a street that no longer exists, where the Peabody Opera House stands today, that would because of its notoriety result in the clearance of hundreds of structures that stood within the central corridor of downtown St. Louis where the Gateway Mall is today. Twenty-two-year-old Frankie Baker shot and mortally wounded eighteen-year-old Allen Britt as they argued over his two-timing her with another woman. The shooting took place at 212 Targee Street[181] in an apartment they shared in one of the city's infamous red-light districts.

Britt staggered to the home of his mother a little farther down the street and collapsed, whereupon, according to neighbor Richard Clay (later interviewed by filmmaker John Huston), Britt's mother began wailing, "Frankie's shot Allen!"[182] Allen Britt died four days later in the City Hospital.

Frankie Baker was tried for murder and acquitted on Friday, November 13, 1899,[183] the jury having believed her testimony that she'd shot Britt in self-defense after he'd pulled a knife on her. But she was haunted for the rest of her life by a song penned the very next day by St. Louis street balladeer Bill Dooley that became a national sensation—spawning numerous additional verses, stage plays and movies and earning for St. Louis a reputation as a very dangerous city.

Originally titled "Frankie Killed Allen," it evolved over many performances and recordings into "Frankie & Johnny," becoming the most famous "he done her wrong" ballad in American music. It underwent so many revisions that "Frankie & Johnny" came to be known as a folk song, the composer's

name lost to time. But Bill Dooley was one of the most prolific St. Louis street balladeers of the era, and researchers like newspaper columnist Paul Slade were able to track down the source. Almost four years earlier, Dooley had turned an equally lurid barroom murder into the almost equally famous "Stagger Lee." To this day, both songs continue to be performed by musicians of genres from blues to jazz to rock.

During the Gay Nineties, ballad sheets were popular in St. Louis, as they had been in the British Isles and other parts of the United States for two hundred years. Street balladeers were

Thomas Stearns (T.S.) Eliot (detail from photo with his sister and his cousin, 1934), by Lady Ottoline Morrell.

adept at turning sensational news items into verse, setting them to music and hawking them on street corners for as little as ten cents per copy.[184] If the tune were catchy enough and the story dramatic enough, it caught on and became widely sung.

Tragically, shootings like Allen Britt's were all too common in the vice- and poverty-ridden districts of late nineteenth-century St. Louis. Young Tom Eliot (later known to the world as the poet T.S. Eliot) had just turned eleven when the incident took place several blocks southeast of where he lived with his family at 2635 Locust Street. After he'd made his home permanently in London following his graduation from Oxford University, Tom Eliot would be known to sing "Frankie & Johnny," which he likely learned as a boy from the street balladeers of St. Louis.[185]

In a speech that he delivered on "American Literature and the American Language" at Washington University, St. Louis, on June 9, 1953, Eliot said, "It is self-evident that St. Louis affected me more deeply than any other environment has ever done. I feel that there is something in having passed one's childhood beside the big river, which is incommunicable to those people who have not. I consider myself fortunate to have been born here, rather than in Boston, or New York, or London."[186] T.S. Eliot was awarded the Nobel Prize for Literature in 1948.

# Chapter 12

# BICENTENNIAL ST. LOUIS

N o single place downtown retains more of the mystery and allure of late eighteenth- and nineteenth-century St. Louis than Laclede's Landing, the nine-block area of restaurants, sidewalk cafés and entertainment venues that fronts the Mississippi between Washington Avenue and Laclede's Landing Boulevard, ending on the ridge along North Third Street.

Here the streets remain the narrow width of the colonial period, and huge brick warehouses—many with finely detailed, cast-iron storefronts—line the cobblestone streets. No colonial buildings survive, although you can see where fur trader Jacques Clamorgan's (and later Pierre Chouteau's) house stood, on the main floor of Raeder Place (721–27 North First Street), which replaced it, and where it's etched in glass. So, too, is a nineteenth-century rendering of the Missouri Hotel, where the first general assembly met on the site to prepare for statehood in 1820.

Renamed for the German-born architect who designed it, Frederick W. Raeder, the six-story brick warehouse at 719–27 North First Street, with its stunning cast-iron front, was built for the Christian Peper Tobacco Company between 1873 and 1874. Its masterful and costly 1976–77 restoration and adaptation were facilitated by newly established federal tax credits for historic rehabilitation that spawned a second lifetime for the entire district.[187] Raeder Place is home to the Old Spaghetti Factory Restaurant, which is furnished in a style that reflects the building's Victorian Italianate design.

The Hoffman Brothers Produce Building (1880) at 700 North Second Street, where Elizabeth (Betty) Grable worked summers in her

Hoffman Brothers Produce Building at 700 North Second Street (Laclede's Landing), where Betty Grable worked in her grandparents' store as a girl. *Thomas P. Kavanaugh, ed.*

grandparents' store as a girl before her mother swept her off to Hollywood and put her to work in the movies;[188] the Cutlery Building (1860) at 612 North Second Street,[189] from which Henry Shaw, founder of the Missouri Botanical Garden, amassed a small fortune selling hardware and stainless steel cutlery from his native Sheffield, England; and the Cast Iron Building (1873) at 712–14 North Second Street, from which the Pullis brothers managed one of the most successful ironworks in St. Louis,[190] each reflect the distinctive ways in which architects adjusted to municipal legislation requiring the use of fireproof building materials after the Great Fire of 1849.

Two eighteenth-century commemoratives can be seen as you walk the Landing. One is a paving stone engraved with "Claymorgan Alley," a block north of the Metro station between Second and First Streets, indicating a large parcel of land owned by Jacques Clamorgan, who arrived in St. Louis from the West Indies in about 1785 and became a highly successful merchant, land speculator and judge.[191]

The second is a commemorative plate on the exterior of the Morgan Street Brewery at North Second and Morgan Streets erected by the St. Louis Association of Colored Women's Clubs Inc.[192] in 1966 to identify the site of the Spanish land grant awarded to Esther. Formerly owned by Jacques Clamorgan, Esther sued him for property that he had placed in her name after freeing her to avoid paying taxes on it. When he tried to reclaim it after she'd managed it for several years, she took him to court—and won!

It's appropriate that Laclede's Landing's excellent self-guided tour begins at 720 North Third Street, the Landing Building, because in October 1963, then owner Jimmy Massucci opened a little bistro called Café Louie and began suggesting that the neighborhood would make a great entertainment area, perhaps even better than St. Louis's legendary Gaslight Square, and that it should be called Laclede's Landing because so few St. Louisans remembered who Laclede was.[193]

Although many of the buildings were all but empty, the architecture was remarkable, and the area had an unmistakable charm that Massucci recognized as a potentially perfect setting for sidewalk cafés. With the Gateway Arch going up in the new national park across Washington Avenue, he believed that visitors would be looking for places to eat and things to do after visiting the arch. But he was also convinced that it would not survive outside the permanence of a neighborhood. "If you're going to have a successful entertainment area you have to have people living there, grocery stores, and shops."[194] He would prove right in both respects.

Massucci didn't come from money. He left school in fourth grade and went to work "in tomatoes at Produce Row" on the north riverfront to help out at home. He also wasn't a politician. But he was one of the visionaries of Gaslight Square, earning a reputation as an entrepreneur, and the right people listened.[195]

A former antique dealer and saloon impresario, Massucci was the former mayor of Gaslight Square, once owner of the Golden Eagle Saloon, Vanity Fair Bar and Cellar Door[196] (later Massucci's) and creator of a wonderfully intimate but relaxed Bohemian setting at Café Louie that drew a fascinating and loyal patronage that included bank presidents, journalists, waiters from neighboring restaurants and the city's three-term mayor, Raymond R. Tucker.[197]

Café Louie's small round tables had marble tops, but you dropped your peanut shells on the floor. The walls were covered with wood from telephone booths and mattress ticking and hung with hand-tinted (by Jimmy's wife, Marilyn Burroughs Massucci) vintage cartoons from *Punch* magazine.[198] A bust of Louis Napoleon held a place of honor, and the poor boy sandwiches were delicious.

Among the newspapermen who met for drinks at Café Louie were Dickson Terry, William Woo, Pat Buchanan and Jack Rice. Massucci's daughter, Toni, who helped out in the café when she wasn't teaching, said that their arguments sometimes grew so loud and vociferous that "dad would put them out."[199] They always came back.

Stories are told of a strangely and specifically cold spot in the basement of the Landing Building, the source of which couldn't be found or remedied (although it provided a welcome natural cooling for water), and a frightening presence where the Massucci family lived above the café. The former has been associated with a safe room for runaway slaves in the cave below and the latter with a woman who was killed during the building's past life as a bordello.[200] The safe room allusion is difficult to prove. It was never publicized.

Jimmy Massucci triggered a revival that led to a host of gathering places on the Landing that stands out in St. Louisans' memories of the late '60s and the '70s, when it flourished. There were very particular and sometimes pungent smells: the sweet aroma of licorice being made in the Switzer Building, which bordered Eads Bridge at the south end of North First Street; the heady scents of roasted coffee and fresh spices from the Old Judge Coffee Building on North Second Street; and the reek of the Bronson Hide Building, which you couldn't get out of fast enough.[201]

Sounds were associated with Laclede's Landing as well: the varied whistles of the boats coming in and out of port; trumpeting sounds from the SS *Admiral* (at five stories the largest riverboat ever built in the United States); the high-pitched whistles of the *Becky Thatcher*, *Tom Sawyer* and *Huck Finn* cruise boats; the tugs making their way up and down the river; trains thundering over the railroad trestle that divided the Landing from Wharf Street; and the *clip-clop* of horses drawing carriages. Not to mention the live bands blaring bluegrass, country and rock music from Muddy Waters at 724 North First Street and Mississippi Nights just a little farther north.

Initial planning for the city's Bicentennial Celebration began even before Jimmy Massucci conceived of Laclede's Landing. But it wasn't until August 1962 that Mayor Raymond Tucker made the public announcement of a "Big Birthday Party in 1964–65 When the City Is 200 Years Old."[202]

There was such a huge response to his call for suggestions that the celebrations would last through 1966, one full year being not quite sufficient to accommodate all of the ideas. A bond issue was passed to fund part of the celebrations and scores of benefits held to supplement it. It would prove to be the largest civic involvement on a long-term project since St. Louis's famed World's Fair of 1904.

The mayor called for "a civic festival of cultural, sports, educational, entertainment, commercial and industrial attractions,"[203] even as the federal government was creating the Jefferson National Expansion Memorial on the riverfront where the central part of the village of St. Louis had once

stood and as the City of St. Louis was constructing "a magnificent new sports stadium," which sadly meant the demise of downtown's small but historic Chinatown. The festival was to have a threefold focus on the history, progress and potential of the St. Louis community.[204]

As of mid-August 1962, the plans for the Gateway Arch to be completed (with the exception of transportation to the top and back) and dedicated in August 1964 were on track. Alas, the National Park Service would not reach its goal and the city would not complete Busch Memorial Stadium in downtown St. Louis during the Centennial Year of 1964–65.

But the St. Louis Cardinals came through in a huge way, bringing a World Series championship trophy home in the autumn of 1964 for the first time since 1946.[205] The season ended in the first Busch Stadium (formerly known as the Grand Avenue Ball Grounds, although St. Louisans continued referring to it as Sportsman's Park) in the northwest part of the city. But grand celebrations, including the parade, took place downtown.

It was a notable World Series for St. Louis. The Boyer brothers faced off against each other—Ken Boyer at third base for the Cardinals and Clete Boyer at third base for the New York Yankees. Yogi Berra, who'd grown up on the Hill in St. Louis, was managing the New York Yankees. Joe Garagiola, who'd grown up in the same block of St. Louis's iconic Italian neighborhood, was announcing the game on radio with Phil Rizzuto. It was the last time the Cardinals would face the Yankees in a World Series. The legendary Stan "the Man" Musial had retired as a player the year before and was now a vice-president of the Cardinals organization, and an unforgettable Bob Gibson pitched the Cardinals to victory in Game 7 and was declared the series MVP.[206]

A lot has been written and said nationally about St. Louis Cardinals fans with respect to their enthusiasm and loyalty. But one of the more or less hidden things about this city is that it is impossible to exaggerate the importance of baseball to St. Louis. It has been over the last five decades the single greatest unifying factor when it comes to the racial, economic, religious and social divisions that have often existed. Part of this is simply due to the magic of the game of baseball itself, the communal spirit that it's able to engender when a team takes a whole community along for a roller coaster ride. Part of it has to do with the number of times the Cardinals have won the National League pennant (nineteen) and a World Series trophy (eleven). But much of it also has to do with the character of baseball in this community.

St. Louis Cardinals Hall of Famer Stan Musial, as he was depicted on his 1953 Bowman baseball trading card. *Courtesy of Bowman Gum.*

The largest statue of a baseball player among the many greats that stand outside Busch Stadium is that of Stanley Frank Musial, who played for the St. Louis Cardinals the entire twenty-two years (excepting two years when he served in the U.S. Navy, 1945–46) that he played professional baseball.[207] Born in Donora, Pennsylvania, in 1920, Stan Musial made St. Louis his home for seventy-five years and came to represent through his skill, drive and modesty the level of success and integrity one could achieve. Musial is credited with leading St. Louis to three of its eleven World Series Championships but was never known to brag about it.[208]

Stan Musial died in 2013, two years after receiving the Presidential Medal of Freedom, the country's highest civilian award. In 2014, we named the new Mississippi River suspension bridge in his honor—the Stan Musial Veterans Memorial Bridge, just north of downtown.[209] In a tradition of nicknaming people and things that dates to the French colonial era, St. Louisans are calling it simply the "Stan Span."

On September 17, 1963, the *St. Louis Post-Dispatch* announced a "Week's Visit by 'MET' for Bicentennial Celebration," during which the Metropolitan Opera Company of New York performed a series of concerts, one of the musical highlights of a year that would feature other national and international musical festivals.[210]

The *Post-Dispatch* also confirmed in early November that President and Mrs. John Kennedy would attend the opening Bicentennial Dinner hosted by the Press Club of St. Louis and that the president would deliver an address. Tragically, that never occurred. St. Louis mourned with the rest of the nation the assassination of President John Fitzgerald Kennedy on November 22, 1963.

It was President Lyndon B. Johnson, in attendance with Mrs. Johnson, who spoke at the dinner officially opening the city's Bicentennial Celebration on February 14, 1964. There has been, almost from the beginning of the city's important anniversary celebrations, confusion over the date on

which Auguste Chouteau and his crew of thirty broke ground for the fur trading post that became St. Louis, due in part to his penmanship. So, the celebrations are generally held from February 14 through 15.

Highlights of the celebration that took place throughout Bicentennial Year included:[211]

- a reenactment of Pierre Laclede's landing by Boy Scouts;
- academic conferences: one on the "Role of the French in the Mississippi River Valley" headed by historian John Francis McDermott and hosted by Washington University and one on the "Common Heritage of France, the United States and Britain" hosted by the Modern Languages Department of St. Louis University;
- the National Repertory Theater taking up residence in the American Theater Building downtown for a three-week run during which the company performed *The Seagull, Ring Around the Moon* and *The Crucible* and a cast led by Eva Le Gallienne and Farley Granger held seminars for high school and college students;
- a water and sky show sponsored by Famous-Barr Department Store (the May Company) in combination with the annual Fourth of July fireworks display on the downtown St. Louis riverfront, inviting both sides of the river to attend the five-hour festival. Although the Gateway Arch was still a year from completion, a large crowd gathered for the celebration;
- the September 21, 1964 performance of *The Story of a City* by four thousand public and parochial school students, with eight thousand more students in attendance;
- the city's hosting the Fifteenth National Basketball Association All-Star Game on January 13, 1965, with Bob Petit and Lenny Wilkins of the St. Louis Hawks playing for the Western Conference Team. It was a nail-biter, with the Eastern Conference winning by one point, as fans were treated to electric performances by the likes of Jerry West, Oscar Roberston, Bill Russell, Wilt Chamberlain and Elgin Baylor;
- and the National Open Golf Tournament, held at Bellerive Country Club.

During 1964, the Old Post Office, formally the U.S. Custom House and Post Office, became a visitors' center and setting for the "Made in St. Louis Expo" celebrating industry and commerce.[212] Designed in 1872 by Alfred B.

Mullett of the U.S. Treasury Department, St. Louis's Old Post Office ranks in the top ten of the General Services Administration's list of the 2,200 most significant buildings in the United States—seventh for historic importance and sixth for architectural merit.[213]

Intended as an architectural statement of the strength and insolubility of the Federal government following the Civil War, it was constructed as a fortress with an exterior thirty-foot dry moat (to provide daylight and ventilation below street level), retractable metal shutters that could be closed in the event of fire within or attack from without and capable of allowing a train to run beneath it for efficiency and the secure transfer of gold bullion and currency. It opened in 1884 as Federal Treasury for the entire western territory of the United States, and it is a treasure inside and out; its north atrium is home to Daniel Chester French's *Peace and Vigilance*, which originally fronted the building's massive Mansard roof.

On June 10, 1964, one of the most entertaining events of the Bicentennial Year took place on the east side of the Old Post Office, after the 300 block of North Eighth Street between Olive and Locust Streets was lined with paint and tennis greats Earl Buchholz, Rod Laver, Pancho Gonzales and Ken Rosewell played a match while crowds cheered from the sidewalks and office workers watched from the windows of neighboring skyscrapers.[214]

It was, in many respects, a celebratory year, with a national spotlight focused positively on St. Louis. But there was here, as in the rest of the nation, growing tension as black Americans struggled to achieve their civil rights, the U.S. was at war in Southeast Asia and a cultural revolution was revving up.

# THE RIVER, THE ARCH, THE CITY AND ITS CAVES

## THE RIVER

The Mississippi River gave birth to the city of St. Louis and has nurtured it ever since. It borders and sometimes submerges low- to mid-lying stretches of downtown St. Louis, overreaching the channel, and makes no bones about it. For it is, as the Ojibwe (Chippewa) people call it, the "Great River." Pierre Laclede rightly judged in 1763 that when it was in flood there would be no containing it. At the height of the Great Flood of 1993, the Mississippi River reached halfway up the Arch's Grand Staircase and inundated the Illinois side of the American Bottom.

Before the first lock and dam were constructed on the Upper Mississippi at Alton, Illinois, in 1938, the river sometimes froze in winter. You could skate from Missouri to Illinois if you were adventurous enough. Eighteenth- and early nineteenth-century *voyageurs* made sure to get home before winter set in, when the Mississippi became a sheet of ice. After it went up in 1874, Eads Bridge became a spectacular observation deck from which St. Louisans marveled at the surge and power of the current engorged by spring flooding.

I don't know that he ever saw it personally, but by the time Oscar Hammerstein II was writing the lyrics to Jerome Kern's musical score for *Show Boat*, he, like millions of other Americans, had come to perceive the river as the nation's metaphorical passageway, Mark Twain having immortalized it as such in *The Adventures of Huckleberry Finn*. Some of his lyrics included the following, from 1927's "Ol' Man River":

*Dere's an ol' man called de Mississippi*
*Dat's de ol' man dat I'd like to be.*
*What does he care if de world's got troubles?*
*What does he care if de land ain't free?* [215]

Over its lifetime of thousands of years, the Father of Waters carried untold numbers of people and their goods, along with pieces of the land, brush and trees that it had swept away. Before Europeans arrived, it transported Native American slaves, captives taken by one ancient people from another. They would be replaced, almost exclusively, by African Americans until slavery was abolished in 1865. St. Louis then became a destination and the river a conduit for freed men, women and children making their way north to opportunity.

The Mississippi also carried music, even as it made music of its own loud enough to make your heart race—the soothing sounds of waves gently lapping the cobblestone levee, the slap of the current on the prow of a boat or the crash of waves in the wake of a storm.

W.C. Handy arrived in St. Louis in the early part of the twentieth century and slept on the cobblestones of the levee until he found work as a musician. Late in life, he told how he'd "heard the roustabouts singing on the steamboats and it hung in my ears,"[216] inspiring what would come to be known as the "St. Louis Blues." The Mississippi River brought many of the roustabouts—the laborers who did the backbreaking work of loading and unloading the riverboats—up from the South and with them their music, slow and mournful, giving voice to their pain or exuberant with joy in their good times.

The levee was haunted during Handy's sojourn by a woman, who seemed half out of her head, and he avoided her most of the time. But he got close enough to her once to hear her lament, "That man's got a heart like a rock cast in the sea." That sentiment and that line became the basis for one of the greatest blues ballads of all time, which Handy published in Memphis in 1914:

*Got the St. Louis blues, just as blue as I can be*
*That man's got a heart like a rock cast in the sea.*
*Or else he wouldn't have gone so far from me.* [217]

According to William Howland Kenney, author of *Jazz on the River*, "The musical form known as jazz began to make its way up the Mississippi

from New Orleans just after the First World War. During this journey New Orleans jazz evolved into riverboat jazz…hot dance music."[218]

Eighteen-year-old Louis Armstrong would become the most famous of the talented musicians who left the Crescent City for more opportunities in the North, signing with Captain John Streckfuss to play aboard the steamer *Sidney* in April 1919. After hours, he made his way up the bluffs to sit in with black St. Louis musicians in places where ragtime had recently reigned and where the trumpet was replacing the piano as lead instrument.[219]

Most of the music venues of the ragtime and early jazz era were located farther up the bluffs, west of the river. But a saloon that opened at the foot of Chestnut Street in about 1880 "became famous from Minneapolis to New Orleans" as a place where "steamboat captains and millionaires shared drinks with Mark Twain and Eugene Field"[220] as they listened to emerging forms of American music.

The Old Rock House, as it came to be known, began life in 1818 as the rubble-stone warehouse of trader Manuel Lisa. Fortunately bypassed by the Great Fire of 1849, when James Clemens Jr. (Mark Twain's cousin) operated

"The St. Louis Cotton Club Band." *Missouri History Museum, St. Louis. Photographs and Prints Collection. N27534: Block Brothers Studio Collection.*

it as a sail maker's shop producing canvas for covered wagons, it lived on as an ironworks and later a produce business.[221]

Over time, a second floor was added, along with an attic story beneath a mansard roof that contained the small bedrooms of a railroad hotel, with the first floor operating as a saloon.[222] By the 1880s, the second floor had become a nightclub known as the St. Louis Cotton Club, where a jazz ensemble led by a great and raucous singer, "Rock House Annie" Richardson, packed the house. They say that one night, having made his fame elsewhere, W.C. Handy returned to St. Louis and arrived in a limousine to hear them perform[223] where the Old Rock House faced the mighty Mississip on Wharf Street (today Lenore K. Sullivan Boulevard).

Sara Teasdale and Tom Eliot, who spent most of their lives in New York and London, were never in memory far from their childhood home and the river that inspired it:

"SUNSET: ST. LOUIS"

Hushed in the smoky haze of summer sunset,
When I came home again from far-off places,
How many times I saw my western city
Dream by her river.
Then for an hour the water wore a mantle
Of tawny gold and mauve and misted turquoise
Under the tall and darkened arches bearing
Gray, high-flung bridges.
Against the sunset, water towers and steeples
Flickered with fire up the slope to westward,
And old warehouses poured their purple shadows
Across the levee.
High over them the black train swept with thunder,
Cleaving the city, leaving far beneath it
Wharf-boats moored beside the old side-wheelers
Resting in twilight.

—Sara Teasdale[224]

"THE DRY SALVAGES"

I do not know much about gods; but I think that the river
Is a strong brown god—sullen, untamed and intractable...

*His rhythm was present in the nursery bedroom,*
*In the rank ailanthus of the April dooryard,*
*In the smell of grapes on the autumn table,*
*And the evening circle in the winter gaslight.*
—*T.S. Eliot, "Four Quartets," 1941*[225]

# THE ARCH

Eero Saarinen designed his magnificent arch to soar beside the river, and soar it has since 1965, casting a shadow that spans the Mississippi for a part of each sunny day much as James Eads's triple arches first spanned its waters.

According to historian Bob Moore Jr., President Franklin D. Roosevelt created the Jefferson National Expansion Memorial with an executive order on December 21, 1935, after native Illinoisan and prominent St. Louis attorney Luther Ely Smith suggested a riverside park and national memorial to President Thomas Jefferson and the pioneers who settled the West.[226] This plan resulted in the destruction of forty city blocks fronting the Mississippi in what had originally been the center of colonial St. Louis, from which Lewis and Clark had departed for their western expedition in 1804 and to which they returned in 1806.

The agreement has proven to be a mixed blessing. St. Louisans love their riverfront, but for a long period of time while the park was being created—and more recently, as it has undergone tremendous renovation—a great part of the area has been inaccessible to the public.

A steel framework covered with stainless steel plates, the Gateway Arch is constructed with 4,644 cubic tons of steel, built to withstand tornado-force winds and designed to last one thousand years.[227] Among its most striking hidden features are the legs sunk to bedrock at a depth of forty-five feet and the reinforced concrete that fills them to the three-hundred-foot mark.[228]

The Gateway Arch in downtown St. Louis symbolizes stability, vision and westward expansion. But on July 14, 1964, it came to represent something more when civil rights activists Percy Green II, a black social worker, and Richard Daly, a white college student, climbed the south leg and chained themselves to the framework of the work ladder 125 feet up, remaining for six hours until they were arrested for trespassing.[229] According to Green, this act of civil disobedience was a way of getting the attention of "the Federal

Government to increase opportunities for black workers in the construction industry and to re-evaluate the hiring practices of contractors and especially trade unions."[230]

A subsequent review revealed that no black workers held skilled jobs—carpentry, ironwork, concrete masonry, crane operation—above the level of laborers on the project. Within a few weeks, the National Park Service contractor had opened work to three black firms, and the charges against Green and Daly were dropped by the federal government. Labor disputes ensued but were peacefully resolved.[231] According to historian Bob Moore Jr. of the National Park Service, "The extraordinary protest at the Gateway Arch on July 14, 1964 by Percy Green and Richard Daly dramatized employment restrictions and led to a government response that resulted in the first direct actions of the Federal Government to enforce equal employment opportunity nationwide."[232]

There are two more hidden features of the arch worth noting: an expanded underground museum, the contents of which have been kept tightly under wraps until its reopening, and a time capsule in the form of an oblong box that was welded into the keystone of the Arch in October 1965.[233]

# THE CITY AND ITS CAVES

The oldest house in downtown St. Louis, dating to 1845 (possibly 1829), is the Eugene Field House and St. Louis Toy Museum at 634 South Broadway.[234] Like the Campbell House Museum on Locust Street, it is a place of charm and mystery, though very different in style. Like Campbell House, it is almost hidden from view, dwarfed by the substantial structures that surround it.

Once part of a long stretch of red brick row houses with identical windows and entrances, it alone was saved from demolition in 1936 because of its distinction as the boyhood home of humorist, father of the personal column in American journalism and "poet of childhood,"[235] Eugene Field, who lived there until he was seven following the death of his mother, Frances.

However, in recent years, its fame has grown to include his father, Roswell, who represented Dred Scott and his family in their suit for freedom when Eugene was a small boy. As he worked in journalism, Eugene Field collected books (more than 3,500—many of them for children—in particular folk tales from around the world)[236] and toys (of which mechanical ones were his favorites).

Eugene Field House and St. Louis Toy Museum, the oldest residence in downtown St. Louis. *Thomas P. Kavanaugh, ed.*

Field rose to prominence as a poet with his publication of "Little Boy Blue" in 1888, which dealt poignantly with a parent's loss of a child, something he and his wife, Julia, personally experienced. They were the parents of eight children, three lost in childhood.[237] In the poem, a little boy's toys wait for him to come back and play long after he has died.

The house's distinct aura of mystery stems from its particular appeal to children, who have for more than four generations found in Eugene Field a kindred spirit, and to the fact that a bookcase that he'd owned in Chicago is opened when locked, without the key, by someone unseen.

A new wing of the Eugene Field Museum opened to the public in 2016, making the main floor of this intriguing family house museum handicap accessible for the first time. The last time Mark Twain visited St. Louis, in 1902, he presided over the dedication of a commemorative plaque designating the building as the boyhood home of Eugene Field.[238]

Eugene Field, poet and journalist. *Courtesy of the Field House Museum, St. Louis.*

## *The Caves*

Much of the city of St. Louis evolved over a labyrinth of natural, limestone caves. It's said to contain more caves than any other city in the nation. Downtown St. Louis sits atop many of them. To the disappointment of many visitors and residents, none of these presently lies open to the public, although during the nineteenth and early twentieth centuries, they were used for everything from underground breweries to a beer garden, opera house, hideouts for street kids and gangsters and, during Prohibition, speakeasies.

The volume of traffic on city streets, the weight of downtown skyscrapers and warehouses and the former illicit uses of many of these subterranean cavities preclude their access in the twenty-first century. Many of them have been filled in with rubble (oftentimes the remains of earlier structures so that new ones could go up in their place), and the entrances leading from one tunnel to another have been sealed for security purposes.

However, some of them remain in use for municipal purposes (steam heat for some downtown buildings is piped from the river through cave channels). Owners of private buildings that have caves beneath them sometimes allow cave archaeologists limited visiting privileges in order to record what's below ground, which is how the images of Philadelphia Cave in the northwest area of downtown St. Louis came to light—so to speak.

Michael Schoenewies of CAIRN (Cave Archaeology Investigation and Research Network) generously shared with me the organization's images of Philadelphia Cave[239] that appear in this book and described his experience

Philadelphia Cave, the interior of one of St. Louis's many subterranean breweries. *Courtesy of Michael Schoenewies and CAIRN.*

Nineteenth-century beer bottles in Philadelphia Cave. *Courtesy of Michael Schoenewies and CAIRN.*

in one of numerous natural St. Louis caves that was adapted for breweries—finished off with brick walls and arches leading from one room into another. Sent by an owner to investigate an area below his building, Schoenewies and his associates found "tons of nineteenth century glass beer bottles of quite a few shapes and sizes." They also found smaller amounts of crockery, perfume bottles and broken glass probably discarded in ice chutes as debris.[240]

The area they explored included at least three sections of barrel vaults and an old stairwell. They also encountered what appeared to be a double vault—that is, another level of cave beneath the one they were in, which they did not enter because it contained a lot of water, the depth of which they couldn't ascertain.

Cave archaeologists like Michael Schoenewies and his wife, Jessi; Craig Williams; and Susie Jansen of CAIRN are explorers at heart with a deep interest in documenting this very well-hidden subterranean part of St. Louis history. They are, in a sense, the intellectual descendants of Hubert and Charlotte Rother, husband-and-wife authors of the fascinating *Lost Caves of St. Louis*.[241] Written in 1964 but unread until 1996 for want of an interested publisher, *Lost Caves* contains their extensive and finely compiled research into the city's intriguing caves: maps, an index of city caves, architectural renderings of the interiors of some and wonderful information relating to as many of these as they could document like Uhrig's Cave between Locust Street and Washington Avenue, beneath the ridge along Jefferson Avenue.

Developed by German brothers Ignatz and Franz Uhrig to promote their nearby brewery, it was expanded from the original location they'd purchased from Dr. William Beaumont into succeeding caverns, creating an underground beer garden that advertised picnics and band concerts.[242] Used by the Home Guard for training in the first year of the Civil War, the Uhrigs sold it in about 1884 to Thomas McNeary and his brothers, who further embellished it into an opera house that could seat an audience of three thousand. The Hess Opera Company performed Gilbert and Sullivan's *H.M.S. Pinafore* there, among other productions.[243]

Included in the many fascinating downtown hollows detailed by the Rothers are the Winkelmeyer and Excelsior Cave near Union Station (that proved to be part of the Uhrig Cave System, which is many blocks long and wide) and Indian Cave, composed of a series of limestone rooms that could be entered by burrowing into the Big Mound before it was completely demolished. They end their marvelous little book by relating how schoolboys once played hooky, gathering there with lighted candles inside a cave beneath a Mississippian Mound dated to approximately the year 1000.[244]

Aboveground cave at City Museum, St. Louis. *Courtesy of Rick Erwin, City Museum. Thomas P. Kavanaugh, ed.*

City Museum rooftop. *Courtesy of Rick Erwin, City Museum. Thomas P. Kavanaugh, ed.*

Deeply disappointed that no part of the natural cave system reached beneath the International Shoe Company between Washington Avenue and Delmar and Fifteenth and Sixteenth Streets, the late, great Bob Cassilly and his artist cohorts created a ten-story, aboveground cave inside their now internationally renowned City Museum. With concrete walls that morph into salamanders, dragons and other sinuous phantasms, the Cave at City Museum is one of the true hidden wonders of downtown St. Louis. Well lit and dry, with restaurants and restrooms not too distant when required, it fulfills the previously unfulfilled wishes of St. Louisans and tourists who cannot access the city's natural caves, unleashing enormous amounts of joy and adventure.

City Museum is secreted with many hidden passageways, hair-raising slides and death-defying climbing structures and is topped off with a rooftop amusement park that features a full-scale Ferris wheel with amazing sightlines, making it the most magical hiding place downtown.

It's also a literary landmark. A struggling young playwright named Tom Williams, who would later adopt the nickname Tennessee, worked in the warehouse of the International Shoe Company (today home to City Museum) after leaving college. Tennessee Williams, who hated St. Louis, set his most autobiographical play here, *The Glass Menagerie*, which deals powerfully, poignantly, with family dysfunction and mental illness. Williams would later use the name of a fellow factory worker for the gentleman caller in *Menagerie* and borrow the name of another, Stanley Kowalski, for the lead character in his Pulitzer Prize–winning *A Streetcar Named Desire*.[245]

I'm hopeful that one of the amazing artists at City Museum will someday sculpt a cat for the top of its tin roof or maybe a glass unicorn for the rooftop garden so that Tennessee Williams's St. Louis past there will not remain hidden. Artist Bob Cassilly and his City Museum have been credited with jump-starting the tremendous architectural and residential renaissance, making new history in Downtown St. Louis today. There's nothing hidden about that!

# Notes

## Chapter 1

1. Iseminger, *Cahokia Mounds*, 17–48.
2. Mink, *Cahokia*, 25–26.
3. Iseminger, *Cahokia Mounds*, 17–48.
4. Ibid., 17–48.
5. Peale, "Ancient Mounds in St. Louis, Missouri," 386–91.
6. Ibid.
7. Chapman, *Archaeology of Missouri*, vol. 11, 169.
8. Leach, *Uncovering Ancient St. Louis.*
9. Ibid.
10. Thwaites, *Travels and Explorations.*
11. Pauketat, *Ancient Cahokia and the Mississippians.*
12. Catlin, "Tchung-kee," in *Letters and Notes*, vol. 1, no. 4.

## Chapter 2

13. Hodes, *Beyond the Frontier*, 19.
14. McCafferty, "Correction: Etymology of Missouri," 79.
15. Pritzer, *Native American Encyclopedia*, 337.

16. Thwaites, *Travels and Explorations*.
17. Christian, *Before Lewis and Clark*; Billon, *Annals of St. Louis*, 19.
18. Hodes, *Beyond the Frontier*, 17.
19. Ibid.
20. Thwaites, *Travels and Explorations*.
21. Baird, *Quapaws*, 14.
22. Liebert, *Osage Life and Legends*.
23. Burns, *History of the Osage People*.
24. Hoessle, *Under Three Flags*, 36.
25. Hodes, *Beyond the Frontier*, 151.

# CHAPTER 3

26. Fausz, *Founding St. Louis*, 38.
27. Ibid., 31.
28. Ibid., 28.
29. McDermott, *Private Libraries in Creole St. Louis*, 13–14.
30. Fausz, *Founding St. Louis*, 31.
31. Ibid., 40.
32. Ibid., 15.
33. Billon, *Annals of St. Louis*, 19.
34. Ibid., 77.
35. Ibid.
36. Ibid., 28.
37. Fausz, *Founding St. Louis*, 86.

# CHAPTER 4

38. Fausz, "Laclede's Lasting Legacies."
39. Moore, "St. Louis in 1804."
40. Fausz, *Founding St. Louis*, 95–105.
41. Ibid.
42. Ibid., 104–6.
43. Billon, *Annals of St. Louis*, 19.
44. Peterson, *Colonial St. Louis*, 24–30.

45. Ibid.
46. Christian, "Laclede-Chouteau Family Tree," *Before Lewis and Clark*.
47. Billon, *Annals of St. Louis*, 21.
48. Ibid., 97.
49. Franzwa, *Old Cathedral*.
50. Hodes, *Beyond the Frontier*, 99.
51. Ibid.
52. Missouri Department of Transportation, "Madame Haycraft (23SL2334) and Louis Beaudoin (23SL2369) Sites."
53. Ibid.

# CHAPTER 5

54. Billon, *Annals of St. Louis*, 97.
55. Hodes, *Beyond the Frontier*, 183.
56. Billon, *Annals of St. Louis*, 205.
57. Hodes, *Beyond the Frontier*, 191.
58. Ibid., 178.
59. Ibid., 185.
60. Brennan and Cannon, *Walking Historic Downtown St. Louis*, 18.
61. McDermott, "Battle of St. Louis, 26 May 1780," 140–41.
62. Hodes, *Beyond the Frontier*, 189.
63. Ibid.
64. Ibid., 190.
65. "Cameron," "Battle of Fort San Carlos."
66. Hodes, *Beyond the Frontier*, 193.
67. Ibid.
68. Brennan and Cannon, *Walking Historic Downtown St. Louis*, 18.
69. Ibid.

# CHAPTER 6

70. Fausz, "Laclede's Lasting Legac.
71. Lankiewicz, "Camp on Wood River," 115–20.
72. Hodes, *Beyond the Frontier*, 299.

73. Ibid., 302.

74. Danisi, *Uncovering the Truth About Meriwether Lewis*, 178–91.

75. Ibid.

76. Moore, "St. Louis in 1804."

77. Danisi, *Uncovering the Truth About Meriwether Lewis*, 186–88.

78. Moore, "St. Louis in 1804."

79. Moore, "Pompey's Baptism," 16–19.

80. Ibid.

81. Ibid.

82. Ibid.

# CHAPTER 7

83. Archives of the Campbell House Museum, St. Louis.

84. Hodes, *Beyond the Frontier*, 520.

85. Ibid., 396.

86. Ibid., 518–45.

87. Ibid.

88. Ibid.

89. Ibid.

90. *Missouri Republican*, "To Enterprising Young Men."

91. Barbour, *Jedediah Smith*.

92. Wright, *African Americans in Downtown St. Louis*, 18.

93. Hafen and Ghent, *Broken-Hand*.

94. Vestal, *Jim Bridger Mountain Man*.

95. Nester, *From Mountain Man to Millionaire*, 19.

96. Ibid., 107–8.

97. Ibid.

98. Brennan and Cannon, *Walking Historic Downtown St. Louis*, 22.

99. Nester, *From Mountain Man to Millionaire*, 107–8.

100. Baird, *Hawken Rifles*, 1–5, 68.

101. Faherty, *Saint Louis Portrait*, 60–61.

102. Ibid.

103. Nester, *From Mountain Man to Millionaire*, 150.

# Chapter 8

104. O'Neil, "Look Back: Great Fire of 1849."
105. Ibid.
106. Ibid.
107. Hillig, "St. Louis Fire Department Remembers an Early Hero."
108. Donahue, "Much of St. Louis."
109. Corbett, "Map and List of Mines in the Cheltenham (Dogtown) Area."
110. Thompson, "Brick First in St. Louis."
111. Finneman, "Geology and Mineral Resources."
112. Gay, "Thieves Cart Off St. Louis Bricks."

# Chapter 9

113. Toft, with Josse, *St. Louis.*
114. Ibid.
115. Gerteis, *Civil War St. Louis*, 26–29.
116. Ibid.
117. Hodes, *Rising on the River*, 721.
118. Ibid., 699.
119. Winter, *Civil War in St. Louis*, 3.
120. Ibid., 36–53.
121. Kathy Petersen, June 11, 2016 interview with the author.
122. Winter, *Civil War in St. Louis*, 52.
123. Ibid., 63–64.
124. Ibid., 69–70.
125. Ibid., 77–78.
126. Wright, *African Americans in Downtown St. Louis*, 14.
127. Ibid.
128. Ibid.
129. Ibid.
130. Winter, *Civil War in St. Louis*, 27.
131. Faherty, *Saint Louis Portrait*, 63.
132. Ibid.
133. Winter, *Civil War in St. Louis*, 31–32.
134. Ibid.
135. McClellan, "Commemorating Eliza Haycraft."

136. Shepley, *Movers and Shakers*.

137. McClellan, "Commemorating Eliza Haycraft."

138. Ibid.

139. Faherty, *Saint Louis Portrait*, 82.

140. Winter, *Civil War in St. Louis*, 85–86.

141. Gerteis, *Civil War St. Louis*, 205–28.

142. Ibid.

143. Ibid.

144. Ibid.

145. Ibid., 230–33; Winter, *Civil War in St. Louis*, 91–93; Fausz, *Historic St. Louis*, 77–78.

146. Ibid.

147. Winter, *Civil War in St. Louis*, 93.

148. Fausz, *Historic St. Louis*, 78.

# Chapter 10

149. Auguste Chouteau, "Narrative of the Settlement of St. Louis," in *Early Histories of St. Louis*, ed. John Francis McDermott, 48.

150. Schmidt, "Mark Twain Quotations."

151. Paine, *Mark Twain*.

152. Twain, *Old Times on the Mississippi*.

153. Patterson, *Great American Steamboat Race*.

154. Ibid.

155. Ibid.

156. Charlson, "Secrets of a Master Builder," *American Experience*.

157. Ibid.

158. Kirschten, *Catfish and Crystal*, 231–43.

159. Ibid.

160. Charlson, "Secrets of a Master Builder," *American Experience*.

161. Archives of the Campbell House Museum.

162. Ibid.

163. Ibid.

164. Dry and Compton, *Pictorial St. Louis*, Plate 42.

165. Ibid.

# Chapter 11

166. Toth, *Kate Chopin*, 1–10.
167. Absher, "William Marion Reedy."
168. Ibid.
169. Crawford, *Young Eliot*, 42.
170. Kathy Petersen, June 11, 2016 interview with the author.
171. Wright, *African Americans in Downtown St. Louis*, 43.
172. African American Registry online, "Tom Turpin Was an Early Ragtime Icon."
173. Wright, *African Americans in Downtown St. Louis*, 44–45.
174. Ibid.
175. Ibid.
176. Stevens, *St. Louis*.
177. State of Missouri, *Wainwright State Office Building*.
178. Sullivan, "Tall Office Building."
179. Toft, with Josse, *St. Louis*, 68–69.
180. McCue and Peters, *Guide to St. Louis Architecture*, 54–55.
181. *St Louis Globe Democrat*, "Negro Shot by Woman."
182. Slade, "It's a Frame-Up."
183. Ibid.
184. McClure, "Real Story of Frankie & Johnny."
185. Crawford, *Young Eliot*, 22.
186. O'Neil, "Look Back: T.S. Eliot Visits His Hometown," and Eliot, "American Literature and the American Language," 6.

# Chapter 12

187. Toft, with Josse, *St. Louis*, 10.
188. Laclede's Landing Self-Guided Tour website.
189. Ibid., the Cultery Building, 8.
190. Ibid., the Cast Iron Building, 12.
191. Seemater, "Clamorgan Document" and "St. Louis Black History Tour."
192. Wright, *African Americans in Downtown St. Louis*, 11–12.
193. Toni Massucci Kuhlman, May 17, 2016 interview with author.
194. Ibid.
195. Ibid.

196. Kirschten, *Catfish and Crystal*, 407–8.
197. Kuhlman interview.
198. Ibid.
199. Ibid.
200. Ibid.
201. Tom Kavanaugh, shared interview with Toni Kuhlman, May 17, 2016.
202. *St. Louis Post-Dispatch*, "Big Birthday Party in 1964–65."
203. Ibid.
204. Ibid.
205. Halberstam, *October 1964*, 337–50.
206. Ibid.
207. Baseball Hall of Fame, "Stan Musial."
208. Kathy Petersen, June 11, 2016 interview with the author.
209. *St. Louis Post-Dispatch*, "Week's Visit by 'MET.'"
210. Culled from twenty-two envelopes in the Newspaper Clippings Archive in the St. Louis Room of the St. Louis Public Library.
211. Ibid.
212. U.S. Custom House and Post Office Museum, St. Louis.
213. Ibid.
214. St. Louis Public Library Newspaper Clippings Archive.

# Chapter 13

215. Oscar Hammerstein II, "Ol' Man River," 1927.
216. *New York Times*, "W.C. Handy Composer, Is Dead."
217. Handy, "St. Louis Blues."
218. Kenney, *Jazz on the River*, 1–2.
219. Ibid., 64.
220. Missouri Historical Society Library, "Landmarks Letter."
221. Ibid.
222. Peterson, "Manuel Lisa's Warehouse."
223. Viets, "Rock House Is Just Rocks Now."
224. Sara Teasdale, "Sunset St. Louis" (public domain).
225. Eliot, "Dry Salvages," *Four Quartets*.
226. Moore, *Gateway Arch*, 15.
227. National Park Service, "Gateway Arch Fact Sheet."
228. Moore, *Gateway Arch*, 38.

229. Ibid., 61, with Joe Johnson, engineer and assistant director of the National Park Service.

230. Ibid., 78, with Percy Green.

231. Ibid., 79–80, with Robert J. Moore Jr.

232. Ibid.

233. Ibid., 138, with Julius Hunter.

234. O'Neil, "Look Back: Eugene Field's Birthplace."

235. Greene, *Eugene Field*.

236. Ibid.

237. Ibid.

238. O'Neil, "Look Back: Eugene Field's Birthplace."

239. Michael Schoenewies, May 7, 2016 interview with author.

240. Ibid.

241. Rother and Rother, *Lost Caves of St. Louis*, 37–39.

242. Ibid.

243. Ibid.

244. Ibid., 98.

245. Brennan, *Amazing St. Louis*, 150.

# BIBLIOGRAPHY

Absher, Frank. "William Marion Reedy. St. Louis Media History Foundation. http://www.stlmediahistory.org.

African American Registry online. "Tom Turpin Was an Early Ragtime Icon." http://www.aaregistry.org/historic_events/view/tom-turpin-was-early-ragtime-icon.

Baird, David D. *The Quapaws*. New York: Chelsea House Publishing Company, 1989.

Baird, John D. *Hawken Rifles: The Mountain Man's Choice.* Big Timber, MT: Buckskin Press, 1968.

Barbour, Barton H. *Jedediah Smith: No Ordinary Mountain Man*. Norman: University of Oklahoma Press, 2011.

Baseball Hall of Fame. "Stan Musial." baseballhall.org/hof/musial-stan.

Billon, Frederick Louis. *Annals of St. Louis in Its Early Days Under the French and Spanish Dominations, 1764–1804.* St. Louis, MO: Press of Nixon-Jones Printing, 1886.

Brennan, Charles, and Ben Cannon. *Walking Historic Downtown St. Louis.* St. Louis, MO: Virginia Publishing Company, 2000.

Brennan, Charlie. *Amazing St. Louis*. St. Louis, MO: Reedy Press, 2013.

Burns, Louis F. *A History of the Osage People*. Fallbrook, CA: CIGA Press, 1989.

Bushnell, D.L., Jr. "The Cahokia and Surrounding Mound Groups." *Papers of the Peabody Museum of Archaeology and Ethnology, Harvard University* 111, no. 1 (May 1904).

"Cameron." "The Battle of Fort San Carlos." Distilled History, June 5, 2013. distilledhistory.com/battlefortsancarlos.

Catlin, George. *Letters and Notes on the Manners, Customs, and Conditions of the North American Indians*. Vol. 1. London: published for the author, Wiley and Putnam, New York, n.d.

Chapman, Carl, and Eleanor Chapman. *Indians and Archaeology of Missouri*. Rev. ed. Columbia: University of Missouri, 1983.

Chapman, Carl H. *The Archaeology of Missouri*. Vol. 11. Columbia: University of Missouri Press, 1975.

Charlson, Carl, screenplay and production. "Secrets of a Master Builder: How James Eads Tamed the Mighty Mississippi." For *American Experience*, PBS, 1999–2000. pbs.org.

Christian, Shirley. *Before Lewis and Clark: The Story of the Chouteaus, the French Dynasty that Ruled America's Frontier*. Lincoln: University of Nebraska Press, 2004.

City of St. Louis, Missouri. "Remembering Captain Thomas Targee." Department of Public Safety, January 1, 2012. https://www.stlouis-mo.gov/news-media/newsgram/remembering-captain-thomas-targee.cfm.

Corbett, Bob. "Map and List of Mines in the Cheltenham (Dogtown) Area Updated 2004." Webster University website. http://faculty.webster.edu/corbetre/dogtown/history/mines.html.

Crawford, Robert. *Young Eliot*. New York: Farrar, Straus and Giroux, 2015.

Danisi, Thomas C. *Uncovering the Truth About Meriwether Lewis*. Amherst, NY: Prometheus Books, 2012.

Donahue, James. "Much of St. Louis and 23 Riverboats Ravaged by 1849 Fire." http://perdurabo10.tripod.com/ships/id298.html.

Dry, Camille, and Richard Compton. *Pictorial St. Louis: The Great Metropolis of the Mississippi Valley*. St. Louis, MO: Compton and Company, 1875.

Eliot, T.S. "American Literature and the American Language." Address delivered on June 2, 1953, at Washington University–St. Louis, later published in Washington University Studies' *New Series: Literature and Language*, no. 23. St. Louis, MO: Washington University Press, 1953.

———. "The Dry Salvages." *Four Quartets*. New York: Harcourt, Brace and Company, 1943.

Encyclopedia Britannica. "Mississippian Culture." www.britannica.com/topic/Mississippian-culture.

Fagan, Brian M. *Ancient North America*. 4th ed. N.p.: Thames & Hudson, 2005.

Faherty, William Barnaby. *The St. Louis Portrait*. Tulsa, OK: Continental Heritage Inc., 1978.

Fausz, J. Frederick. *Founding St. Louis: First City of the New West.* Charleston, SC: The History Press, 2011.

————. *Historic St. Louis: 250 Years Exploring New Frontiers.* San Antonio, TX: HPNBooks, 2014.

————. "Laclede's Lasting Legacies." Opening lecture at the Founding of St. Louis Symposium, February 14, 2014, at the Missouri History Museum, St. Louis.

Finneman, N.M. "Geology and Mineral Resources of the St. Louis Quadrangle, Missouri-Illinois." *United States Geological Survey Bulletin 438* (1911).

Foster, William C. *Climate and Culture Change in North America.* Austin: University of Texas Press, 2010.

Franzwa, Gregory M. *The Old Cathedral.* 2nd ed. Gerald, MO: Patrice Press, 1980.

Gay, Malcolm. "Thieves Cart Off St. Louis Bricks." *New York Times,* September 19, 2010. www.nytimes.com.

Gerteis, Louis S. *Civil War St. Louis.* Lawrence: University Press of Kansas, 2001.

Gill, McCune. "The St. Louis Story." *Library of American Lives.* Hopkinsville, KY: St. Louis. Historical Records Association, 1952.

Greene, Carol. *Eugene Field: The Children's Poet.* N.p.: Children's Press Inc., 1994.

Hafen, LeRoy R., and W.J. Ghent. *Broken-Hand. The Life Story of Thomas Fitzpatrick, Chief of the Mountain Men.* Reprint, Lincoln: University of Nebraska Press, 1973. Originally published by Old West Publishing Company, 1931.

Halberstam, David. *October 1964.* New York: Villard Books, 1994.

Handy, W.C. "St. Louis Blues." Memphis, TN: Pace & Handy Music Company, 1914.

Hillig, Terry. "St. Louis Fire Department Remembers an Early Hero." *St. Louis Post-Dispatch,* December 11, 2011. http://www.stltoday.com/news/local/metro/st-louis-fire-department-remembers-an-early-hero/article_823e636c-d8b4-5a56-b6c6-2998c80e1ee8.html.

Hodes, Frederick A. *Beyond the Frontier: A History of St. Louis to 1821.* Tucson, AZ: Patrice Press, 2004.

————. *Rising on the River: St. Louis, 1822–1850, Explosive Growth from Town to City.* Tucson, AZ: Patrice Press, 2009.

Hoessle, Maureen. *Under Three Flags: Exploring Early St. Louis History.* St. Louis, MO: Virginia Publishing, 2005.

Iseminger, William. *Cahokia Mounds: America's First City*. Charleston, SC: The History Press, 2010.

Kenney, William Howland. *Jazz on the River*. Chicago: University of Chicago Press, 2005.

Kirschten, Ernest. *Catfish and Crystal*. 3rd ed. St. Louis, MO: Patrice Press, 1989.

Laclede's Landing. "Hoffman's Building." landingtour.mobi/Stops/HoffmanBldg.htm.

Laclede's Landing Self-Guided Tour website. landingtour.mobi.

Lankiewicz, Donald P. "The Camp on Wood River: A Winter Preparation for the Lewis and Clark Expedition." *Illinois Historical Journal* 77 (Summer 1982): 115–20.

Leach, Mark. *Uncovering Ancient St. Louis*. Triptone Productions, 2009.

Liebert, Robert M. *Osage Life and Legends*. Happy Camp, CA: Naturegraph Publishers Inc., 1987.

McCafferty, Michael. "Correction: Etymology of Missouri." *American Speech* (2004).

McClellan, Bill. "Commemorating Eliza Haycraft: Civil War–Era Madam." *St. Louis Post-Dispatch*, September 5, 2014. Stltoday.com. http://www.stltoday.com/news/local/columns/bill-mcclellan/mcclellan-commemorating-eliza-haycraft-civil-war-era-madam/article_5b71330a-9bd9-5bd6-a142-b9b3aee51ee6.html.

McClure, Dudley L. "The Real Story of Frankie & Johnny." *Daring Detective Tabloid* (1935).

McCue, George, and Frank Peters. *A Guide to St. Louis Architecture*. Columbia: University of Missouri Press, 1989.

McDermott, John Francis. "The Battle of St. Louis, 26 May 1780." *Missouri Historical Society Bulletin* 36 (April 1980): 140–41.

———. *Early Histories of St. Louis*. St. Louis, MO: St. Louis Historical Document Foundation, 1952.

———. *Private Libraries in Creole St. Louis*. Baltimore, MD: Johns Hopkins University Press, 1938.

Milner, George R. *The Moundbuilders: Ancient Peoples of Eastern North America*. N.p.: Thames & Hudson, 2004.

Mink, Claudia G. *Cahokia: City of the Sun*. Edited by William Iseminger. N.p.: Cahokia Mounds Museum Society, 1992.

Missouri Department of Transportation. "Madame Haycraft (23SL2334) and Louis Beaudoin (23SL2369) Sites." The Poplar Street Bridge Project: Excavation of French Colonial St. Louis, n.d. modot.org/ehp/sites/Archaeological_Investigations_at_the_Poplar_Street_Bridge.htm.

*Missouri Republican.* "To Enterprising Young Men" advertisement, March 20, 1822.

Moore, Bob, Jr. "Pompey's Baptism." *We Traveled On* 26, no. 1 (February 2000). Official Publication of the Lewis and Clark Trail Heritage Foundation.

————. "St. Louis in 1804." National Park Service. nps.gov/jeff/learn/historyculture website.

Moore, Robert, Jr., ed. *The Gateway Arch, an Architectural Dream: A Collection of Essays Commemorating Jefferson Expansion Memorial.* N.p.: Jefferson National Parks Association, 2005.

National Park Service. "Gateway Arch Fact Sheet." nps.gov./jeff/planyourvisit/gateway-arch-fact-sheet.htm.

Nester, William R. *From Mountain Man to Millionaire: The Bold and Dashing Life of Robert Campbell.* Columbia: University of Missouri Press, 2011.

*New York Times.* "W.C. Handy Composer, Is Dead; Author of 'St. Louis Blues'; 84." Obituary, March 29, 1958. http://www.nytimes.com/learning/general/onthisday/bday/1116.html.

O'Neil, Tim. "A Look Back: Big Mound in St. Louis, Legacy of a Lost Culture, Leveled in 1869." *St. Louis Post-Dispatch*, November 10, 2013. http://www.stltoday.com/news/local/metro/look-back/a-look-back-big-mound-in-st-louis-legacy-of/article_3b006339-444d-575f-91c5-8b4f96fa08cd.html.

————. "A Look Back: Eugene Field's Birthplace Almost Demolished, Opens as a Museum in 1936." *St. Louis Post-Dispatch*, December 18, 2011. http://www.stltoday.com/news/local/metro/a-look-back-eugene-field-s-birthplace-almost-demolished-opens/article_046cf236-ff0e-5fa6-91a3-b308119729ea.html.

————. "A Look Back: Great Fire of 1849 Ravaged Riverfront." *St. Louis Post-Dispatch*, May15, 2011. http://www.stltoday.com/news/local/metro/a-look-back-great-fire-of-ravaged-riverfront/article_ff8faca9-1ba5-5f52-9252-e8397b705240.html.

————. "A Look Back: T.S. Eliot Visits His Hometown in 1933." *St. Louis Post-Dispatch*, January 15, 2012. http://www.stltoday.com/news/local/metro/a-look-back-poet-t-s-eliot-visits-his-home/article_cf10025d-0336-5abb-babd-48651cbc8adf.html.

Paine, Albert Bigelow. *Mark Twain: A Biography.* New York: Harper & Brothers, 1912.

Patterson, Benton Rain. *The Great American Steamboat Race: The* Natchez *and the* Robert E. Lee *and the Climax of an Era.* Jefferson, NC: McFarland, 2009.

Pauketat, Timothy. *Ancient Cahokia and the Mississippians*. Cambridge, UK: Cambridge University Press, 2004.

Paxton, John A. *The St. Louis City Directory*, 1821.

PBS. "A Timeline of the Trip." Lewis and Clark. pbs.org/lewisandclark/archive/1806.html.

Peale, T.R. "Ancient Mounds in St. Louis, Missouri, in 1819." *Annual Report of the Board of Regents of the Smithsonian Institution* (1862).

Peterson, Charles E. *Colonial St. Louis: Building a Creole Capital*. Tucson, AZ: Patrice Press, 2001.

———. "Manuel Lisa's Warehouse." *Missouri Historical Society Bulletin* 4, no. 2 Issue (January 1948). Missouri Historical Society Library.

Primm, James N. *Lion of the Valley: St. Louis, Missouri*. Boulder, CO: Pruett Publishing, 1981.

Pritzer, Barry M. *A Native American Encyclopedia: History, Culture and Peoples*. New York: Oxford University Press, 2000.

Repps, John W. *Saint Louis Illustrated: Nineteenth-Century Engravings and Lithographs of a Mississippi River Metropolis*. Columbia: University of Missouri Press, 1989.

Rother, Hubert, and Charlotte Rother. *The Lost Caves of St. Louis*. St. Louis, MO: Virginia Publishing Company, 1996.

Schmidt, Barbara. "Mark Twain Quotations, Newspaper Collections, and Related Sources." Twain Quotes. www.twainquotes.com.

Seemater, Mary. "Clamorgan Document" and "St. Louis Black History Tour." Lecture notes shared with the author.

Shepley, Carol Ferring. *Movers and Shakers, Scalawags and Suffragettes: Tales from Bellefontaine Cemetery*. St. Louis, MO: Museum History Press, 2008.

Slade, Paul. "It's a Frame-Up: Frankie & Johnny." Planet Slade, 2013. http://www.planetslade.com/frankie-and-johnny.html.

Smith, Bruce D. *The Mississippian Emergence*. Tuscaloosa: University of Alabama Press, 1990.

*St. Louis Globe Democrat*. "Negro Shot by Woman." October 16, 1899.

*St. Louis Post-Dispatch*. "Big Birthday Party in 1964–65 When the City Is 200 Years Old." August 10, 1962.

———. "Week's Visit by 'MET' for Bicentennial Celebration." September 17, 1963.

Staff of the Landmarks Association of St. Louis. *Landmarks Letter* 31, no. 1 (January/February 1996). Available at the Missouri Historical Society Library, St. Louis.

State of Missouri. *Wainwright State Office Building*. Brochure, n.d.

Stevens, Walter B. *St. Louis: The Fourth City, 1764–1911*. Vols. 1 and 2. St. Louis, MO: S.J. Clarke Publishing Company, 1911.

Sullivan, Louis. "The Tall Office Building Artistically Considered." *Lippincott's* (March 1896).

Thompson, Jacob. "Brick First in St. Louis." ATEK Company website. https://stlbrickrepair.com.

Thwaites, Reuben Gold, ed. *Travels and Explorations of the Jesuit Missionaries in New France, 1610–1791, Voyages Du P. Jacques Marquette, 1673–75*. Cleveland, OH: Burroughs Company, Imperial Press, 1899.

Toft, Carolyn Hewes, with Lynn Josse. *St. Louis: Landmarks & Historic Districts*. St. Louis, MO: Landmarks Association of St. Louis, 2002.

Toth, Emily. *Kate Chopin*. New York: William Morris and Company Inc., 1990.

Twain, Mark. *Old Times on the Mississippi*. Electronic ed. Text scanned and encoded by Jill Kuhn. Documenting the American South, University of North Carolina–Chapel Hill. http://docsouth.unc.edu/southlit/twainold/twain.html.

Vestal, Stanley. *Jim Bridger: Mountain Man*. New York: William Morrow Company, 1946.

Viets, Elaine. "The Rock House Is Just Rocks Now." *St. Louis Post-Dispatch*, June 14, 1988.

Winter, William C. *The Civil War in St. Louis: A Guided Tour*. St. Louis, MO: Missouri Historical Press, 1947.

Wright, John A., Sr. *African Americans in Downtown St. Louis*. Charleston, SC: Arcadia Publishing, 2003.

# ABOUT THE AUTHOR

Maureen Kavanaugh is a St. Louis Tour Guide specializing in the history of the Greater St. Louis area from the year 1000 to the present. She publishes a Wordpress blog (https://stltourguide.wordpress.com) on St. Louis history, landmarks, events and people, and since 2010, she has written spiritual reflections for children for Bayard Publishing's "Living Faith Kids."

Before she began writing, she was a K-3 classroom teacher and K-8 art instructor. Her interests include history, archaeology, art and music of all kinds. She is a voracious reader, occasionally performs Irish traditional and original music with her family and loves to walk! Her favorite literary genres are poetry and mystery fiction.

She is the author of *The Campbell Family of St. Louis: Their Public Triumphs and Personal Tragedies*, published by the Campbell House Museum in St. Louis in 2016.